Contents

THE ARTIST'S GUIDE TO
SELLING WORK__

ANNABELLE RUSTON

 Published by Fine Art Trade Guild & A&C Black

First published in Great Britain 2005
A&C Black Publishers
38 Soho Square
London W1D 3HB
www.acblack.com

Some content first published 1996 as *Artists & Galleries: A Profitable Relationship* in association with the Society of London Art Dealers
Revised, expanded and updated 2005 as *The Artist's Guide to Selling Work*

Reprinted 2006, 2007

ISBN-13: 978-0-7136-7159-9

Preface © Anita Klein, PRE

Researched and edited by Annabelle Ruston
Copyeditor: Julian Beecroft
Page and cover design: Peter Bailey
Project manager: Susan Kelly
Editorial assistant: Sophie Page

A CIP catalogue record for this book is available from the British Library

Although every effort has been made to ensure that all the information in this publication is correct, the Fine Art Trade Guild and A&C Black cannot be held responsible for any errors or for financial transactions made on the basis of information in this publication.

Fine Art Trade Guild
16–18 Empress Place, London SW6 1TT
Tel: 020 7381 6616 Fax: 020 7381 2596
info@fineart.co.uk
www.fineart.co.uk

This book is produced using paper that is made from wood grown in managed, sustainable forests. It is natural, renewable and recyclable. The logging and manufacturing processes conform to the environmental regulations of the country of origin.

Printed and bound by Cromwell Press, Trwobridge, Wiltshire

Promotion and promotional costs
Transport
Bankruptcy
Gallery owners as agents

Studio sales
Rented gallery space
Consumer art fairs
Trade exhibitions
The Internet
Field sales
Publicly funded opportunities
Exhibiting societies
Competitions

The visitor profile
Direct costs
Displaying the work
Taking money
Sales literature
Advertising and publicity
Pre-show contact
Special offers and other attractions
Face-to-face selling
 Contact with the artist
 Enthusiasm
 Existing customers
 Body language
 Closing a sale
Follow-up

Acknowledgements

Thanks are due to the following for advice and information on the intricacies of the art market:

Keith Andrew; Simon Ashworth of Helensburgh Fine Arts; Mark Azopardi of The Three P's; Christopher Battiscombe of Society of London Art Dealers; Simon Bull; Keith Cast of Dorset Fine Arts; Alexandra Clark; Ron Cosford; Peter Crisford of Inspired Frames; Robert Crofts of The Framer's Workshop; Rowland Davidson; Jonathan Dodd of Waterhouse & Dodd; Barry Everitt of Barry Everitt Associates; Matthew Flowers of Flowers East; Keith Gardner; John & Penny Gillo of John Gillo Gallery; Anna Greenacre of Berkeley Square Gallery; Julie Harris; Peter Hart of Victoria Gallery; Nigel Hemming; Warwick Higgs; Malcom Hord of the London & Provincial Antique Dealers' Association; Christopher Insoll of The Gallery, Portscatho; Mark Jerram of The Jerram Gallery; Paula Kenevan of Possi; Jennie Kuca of The Post Office Gallery; Andrew Lamont of Lamont Gallery; James Lloyd of Burlington Paintings; Jennifer Mathur of Ditchling Gallery; Pip McGarry; David McLean of David McLean Associates; Denise Outlaw of ARC Prints & Frames; the late Sir Eduardo Paolozzi RA CBE; Sam Phillips of License Europe; Godfrey Pilkington of Piccadilly Gallery; Frankie Rossi of The Gallery at John Jones; Lynn Sell of Lynn Sell Gallery; Keith Siddle; Mike Sims of Art Business Today; Brian Sinfield; John Stoa of Original Art; Rosie Sumner of Fine Art Trade Guild; Maggie Thornton of Redfern Gallery; Veronica Wood of Michael & Veronica Wood.

Preface

There is nothing wrong with selling art. It is also true that nobody becomes an artist in order to grow rich. The drive to make art tends to come not only because someone is good at drawing, but out of a need to express oneself visually, to say something with images that cannot be expressed in words. Many artists confuse this purity of intention with a compulsion to shun all talk of money. However those of us with mortgages and children to feed eventually realise that we must either sell our work, or get another job, probably both. Combining making art and a job into a busy life leads many artists to say that they do not have time for 'paperwork' or marketing their art. It is often overlooked that the more art you sell, the more time you will have to work.

Most great art produced before the twentieth century was made in response to a commission, i.e., for money. That does not mean that the artist's inspiration and quest for perfection were any less absolute. Artwork that is sold not only briefly feeds the artist's family, it also is seen and enjoyed by the buyer. For me this is the most gratifying aspect of selling work; somebody loves it and wants to look at it. Art is a form of communication, and stacking unsold work in a studio is a sad waste. Many artists feel this, which is why some, particularly the young and inexperienced, are prepared to almost give their work away in order for it to be seen. This can be an opportunity for unscrupulous dealers and galleries to make money out of young artists. However, most gallery owners are in business for the love of art, just as much as artists are. This majority would prefer to deal with artists who can be businesslike and professional, just as artists want to deal with galleries who are efficient about sales and payment. The relationship between artist and gallery must be one of mutual trust, and to work it must be built on a foundation of clarity. This book is an invaluable guide to achieving that relationship and ultimately to having more time to sit in your studio and stare into space.

Anita Klein PRE
President, Royal Society of Painter-Printmakers

Introduction

Technology is rapidly making it easier both to produce and market artwork. This lowering of costs is in turn allowing more artists to make a living from their work, but at the same time it is making the art market more competitive than ever before. Thus, to earn a good living artists need to be professional and understand how the art market works.

As an artist creates a work, they are making two commercially viable products: firstly, of course, the work created, and secondly, the copyright in that work. Copyright is an entirely separate commodity from the work itself, and is the artist's to sell outright or to license to a range of users. Artists tend to work with galleries to sell their original work and with publishers and licensees to generate income from their copyright.

Artists, galleries, printers, publishers and licensees rely on each other. This book aims to help all sides to establish a professional and productive working relationship. If each party understands the others' roles in the art market, and thus feels confident in their own position, then the maximum time and energy can go into producing and selling works of art.

Artists are often so flattered to sell their work, or the copyright in an image, that they forget to ask important questions about terms and commission rates. It is not in either party's interests for this to happen. A relationship arranged on a professional footing will be more productive and more enduring, and misunderstandings will be less likely to occur.

Artists often doubt that they are getting a good deal from licensees and galleries, but feel too intimidated to ask for better terms. On the other hand, they often do not fully understand the real costs to gallery owners and publishers of marketing and selling the work. Businesses are often frustrated by artists' lack of commercial knowledge and lament that this is not taught properly at art school. This book aims to help resolve these concerns, and others too.

Advice is targeted at artists seeking to earn a living from their art. Artists who are relatively new to their profession will find this book valuable, as will experienced artists seeking to move into new areas such as licensing or self-publishing, or who need advice on the business side of things.

Sculpture is not specifically addressed. Sculptors are subject to the same general considerations as painters, with the added complication of the cost of producing their work. This can vary enormously – large and heavy sculptures can be expensive to move and install. How these costs are met must be agreed with the gallery owner.

This book explains how to work with UK-based galleries and licensees. It does not touch upon the complexities of international law and global-business customs.

The main difference between this book and *Artists & Galleries: A Profitable Relationship*, which was published in 1996, is the addition of chapters on licensing, self-publishing and working with publishers. The text has also been substantially updated, for example to take into consideration the impact of the Internet and digital printing on the art market.

Chapter 1

The business side of being an artist

It is essential for any professional artist these days to have a computer with a database package and fast Internet access. The best digital camera you can afford is also a good investment, as retaining good-quality photographs of all artwork is essential. You should set some time aside each week for keeping records; if this is done efficiently and regularly it need not take long.

Record keeping

It is important to keep good records. This minimises administration time and maximises the chances of doing repeat business.

There are four key areas in which records must be kept:
1) client lists
2) index of artwork
3) details of sales made and sales in progress
4) records of all financial transactions.

1) Client lists

You will need to develop a mailing list and keep records of who bought what, when, where and for how much. A modern computer

database with searchable fields is straightforward to set up and use. You can then contact clients who buy a particular subject or medium when suitable work becomes available. It should be possible, for example, to email JPEGs to everyone who buys etchings of the Suffolk coast at the push of a button, or to send an email with a web link to the relevant page on a website.

Strong client lists are very appealing to galleries, and can greatly help secure a show at a gallery, so you must keep up-to-date records of all buyers as well as actively seeking new customer details. For example, leave a visitors' book in a prominent place on exhibition stands and ask buyers who seem interested if they would like to be added to your mailing list.

2) Index of artwork

You should code both photographs/JPEGS and original works so that they can be easily identified and located. For example, the abbreviation 'L/1/04', meaning landscape number 1 produced in 2004, could be written on the stretcher frame of the painting, given as the title of the JPEG and noted on a colour laser copy in the artist's filing system. A system of coding helps to keep track of sales and can form the basis of an efficient method of offering images for sale to publishers and other organisations. Otherwise confusion might arise over precisely which image is being discussed.

As a professional artist, you can never have too many high-quality reproductions of your work. These can be useful for generating secondary income at a later date, such as through licensing deals (see Chapter 13: 'Working with publishers and licensing work'). They may also be required for insurance purposes, catalogues, to settle legal disputes, etc. The date that a work was created can be captured indisputably in a photograph.

Successful artists have been known to comment that one of the most important aspects of their careers has been the keeping of large numbers of high-quality reproductions and making sure that all of these images are made to work for them. You should make sure that all sold works are photographed before passing out of your hands; remember that copyright remains the artist's property regardless of who owns the original work (see Chapter 12: 'Copyright and reproduction rights'), and that significant sums can be generated by the copyright in a work over a number of years, but only if high-quality photographs are retained.

It may be necessary to engage the services of a professional photographer, particularly if sold works are going to places that would be inaccessible to a licensee's photographer. Print publishers and other licensees could not produce a print from a poor-quality digital file or photograph.

You should keep the largest-possible digital files of your work. Before buying a digital camera, check that it can produce large image files. The size of a digital file is measured in kilobytes and megabytes, but artists are interested in two further types of measurement: the number of dots per inch (dpi) (referring to how many tiny coloured pixels make up each inch of the image); and the physical dimensions of the image file (the fact that it measures 10 x 10cm, for example).

An image-editing software program such as Adobe Photoshop will allow you to check these measurements. Ideally you need to store your images at two sizes: 'high resolution' files, which can be reproduced as posters and cards, and 'low resolution' files, which can be quickly sent over the Internet and viewed onscreen. Magazines, greetings-card publishers, print publishers and other organisations require images that are 300dpi (high resolution) when scaled to the actual dimensions at which they are to be reproduced. Therefore, if a poster 100cm high is being created, a very large digital file will be required. Images for the Internet only need to be 72dpi (low resolution).

The British Association of Picture Libraries (www.bapla.org) advises artists to store their work at a minimum size of 48 megabytes, which is standard for commercial images across the licensing industry. Images should be stored as RGB files, which hold far more colour information than CMYK files (the latter are suitable for specific printing purposes, but can give disappointing results when used differently). JPEG is a useful format, but remember that each time a JPEG is opened and then re-compressed some data is lost, so be sure to keep some JPEGs on file that will not be manipulated and can be sent in their virgin state to licensees. TIFF files do not suffer the loss of data that occurs when a file is compressed into a JPEG so some customers prefer to receive TIFFS, the problem being that they are larger files for downloading and emailing. Ideally, artists should store their work in both formats.

A large image can be copied and a smaller one retained as well, but a large file cannot be generated from a small one. Remember that computers don't last forever, and are vulnerable to theft or damage, so be sure to store your work on CDs as well as on the computer hard drive.

3) Details of sales made and sales in progress

Proper records help the development of an artist's business. It should be possible to see easily which types of work are selling best, as well as which price ranges and media are going well. It is possible to see patterns in the kinds of art people buy (and the kinds of people who buy) at different times of the year (for example, low-cost items might sell well at Christmas and local scenes during the tourist season).

Databases should include galleries, licensees and other business contacts, and should be updated with notes about ongoing negotiations. For example, you will need to be able to refer to the percentages you are discussing, and what has been agreed with galleries and licensees.

You will also need to know which galleries have which of your works on sale or return, and how much you should expect to get if a work sells. Unprofessional galleries may not notify artists as work sells, so in this case you may need to be proactive in chasing them for payment or to arrange for collection of your work. Sometimes work can sit at the back of the gallery storeroom uncollected if both artist and gallery owner have forgotten about it. You should make sure to collect unsold work quickly, as it won't generate income languishing in a storeroom.

4) Records of all financial transactions

Remember to keep records of all money coming in and money going out. Once you become professional some outgoings may be tax-deductible. Once you earn more than the tax threshold of a few thousand pounds (this figure changes each year, but is currently just under £5,000) you become liable for tax, and may need to register for VAT when your turnover develops (the VAT threshold is currently around £55,000 annual turnover).

Keeping financial records will also help you to understand how much money you have coming in each month to live on, and the extent of the business overheads you need to cover. This will help when pricing work; though pricing art is more complex than just a reflection of business overheads, these do represent a bottom line. Records also mean, for example, that you can look back at how much a particular exhibition or marketing exercise cost you, and so decide whether it is worth doing again.

Marketing

We live in a market-led era, and thus it is important to adopt the appropriate skills. Artists who wander onto stands at art fairs and say "Hello. Do you buy pictures at all?" are unlikely to succeed. The well-worn caricature of the undisciplined, capricious, bohemian artist who would prefer to drink absinthe in a café than tout work around galleries is even less likely to survive today than in nineteenth-century Paris (in fact, very few survived even then).

Have a marketing plan. Know what you are trying to achieve and how you hope to do this. Have a time frame, and realistic objectives, and decide what you will do yourself and what you need to pay others to do. Communication is the key; be sure to send regular invitations, by post or email, to all buyers and potential buyers on your database. Notify them of all events in which you are taking part and any new releases that might be of interest to them. Email marketing and the Internet have made this type of exercise extremely cost-effective: the cost of printing and post can often be avoided.

Some artists are constantly thinking of ways to develop their presentation and image: they look at packaging, fashions in design and the layout of trendsetting magazines, and think how the ideas expressed in these can be adapted to their own use. Perhaps a particular colour of paper or ink should be used throughout, or perhaps a certain typeface would complement the work. What matters most, however, is the clarity of the presentation.

Artist's resale right

The Artist's Resale Right (ARR), also known as Droit de Suite, became law in the UK in 2006. European artists are entitled to royalty payments of up to four per cent on secondary sales of works that are sold by art professionals for more than £1000 (although in some EU countries the threshold is higher). ARR does not apply to most reproductions. ARR royalty payments are collected by several 'collecting' agencies, the lead one being The Design and Artists Copyright Society (DACS). DACS will collect on behalf of any artist, whether registered with them or not, whereas other agencies can only collect on behalf of the artists signed up with them. If you are not registered with an agency, visit www.dacs.org.uk/arr to claim any royalties which may be due to you and to understand the details of the new right.

Chapter 2

The different types of art business

Before approaching anyone, it is important to understand the differences between the main types of art business.

Galleries

Galleries range from high-street picture framers who sell a few reproductions and inexpensive watercolours of local scenes as a sideline, to London dealers selling work internationally for millions of pounds. Galleries tend to sell original work by living artists on a sale-or-return basis. Occasionally they deal with artists' agents (see below), but they usually prefer to work directly with the artist. Galleries selling prints and posters are likely to buy stock from both publishing companies and self-publishing artists (galleries often set up accounts with publishers and are invoiced monthly, but this type of stock may not be returnable if unsold). Galleries selling antique and secondary-market works tend to own their stock, much of which is bought at auction. Most galleries are independently owned and have just one outlet, though there are a few mini-chains operating mid-market with up to ten shops.

Print publishers

Print publishers can be anything from self-publishing artists to large international companies. Rapid developments in desktop-publishing technology are making it easier for businesses to dabble in publishing without massive initial investments, so new publishing companies are founded all the time. A good print publisher will have expertise in selecting commercially viable artwork, and will market and distribute the work effectively to galleries or, in some cases, direct to collectors. Artists who use publishers to produce their work have contracts outlining the terms of their publishing agreement (see Chapter 14: 'Contracts between artists and publishers or licensees').

Licensees

Licensees buy a licence, from an artist or other copyright holder, to use an image for a specific purpose. Licensees include print publishers, greetings-card publishers, ceramics firms, and gift and stationery manufacturers. (See Chapters 12, 13 and 14 for information on the mechanics of copyright and licensing.)

Fine-art printers

It is important to understand the differences between a printer and a publisher. A fine-art printing company will undertake the reproduction of artwork on behalf of an artist or publisher, but plays no role in selecting artwork, marketing it or distributing it. Fine-art printing has some unique requirements for which not all printers have sufficient expertise; even the best magazine printers may not be qualified to produce fine-art prints.

It is also important to understand the difference between reproducing an existing artwork and creating an original print. Original prints differ from reproductions in that they are conceived as such by the artist from the outset; no 'original paiting' exists, only blocks, plates or other printmaking matrices. Fine-art printers are in the business of printing reproductions, not original prints.

Agents

See Chapter 11: 'Agents' for a discussion of the different types of agent and distributor. These range from full-time business managers to agents on the road selling to galleries.

Department stores and retail multiples

The vast majority of the art sold in this country, particularly reproduction prints, is sold via a few retail giants. Some artists complain that big companies inevitably use their market clout to demand hefty discounts, while others worry that upmarket galleries will be put off their work if it has appeared in mainstream shopping venues. The large retailers often make considerable demands on their suppliers in terms of how they organise their sales systems and invoicing and, more importantly, they often want significant input into their suppliers' product development. Some large retailers buy via established publishers and are not interested in dealing direct with artists; similarly, the gallery sections of some department stores are in fact owned and run by the big publishing houses.

The six types of business listed above of course tend to overlap each other's territory. For example, some galleries act as agents for their artists and handle all licensing deals on their behalf. Some fine-art printers also have a publishing arm, and some publishers also own galleries. Some of the large publishing houses operate schemes that bind galleries to buying their product exclusively.

There are of course many other players in the art market, but those listed above are the most significant. Auctioneers tend to focus on work that has an established secondary market, rather than work from emerging artists. Specialist corporate art suppliers are important customers for some artists, but they represent a small sector of the overall marketplace, given that gallery owners and publishers often supply corporate art themselves. Some artists do well selling their work direct via Internet auction houses such as eBay, but this is more of a sideline than a main income stream. Gift shops and online galleries also sell art, but they tend to operate on the same basis as galleries.

Chapter 3

Selecting the right business

It may seem self-evident that as a professional artist you will make best use of your time if you approach businesses that are likely to be interested in your work. But in practice many inexperienced artists waste their time and money approaching the wrong type of gallery, publisher or licensee. Moreover, continual rejection is demoralising. There will probably be no mileage, for example, in approaching galleries that only sell Old Masters, or licensees that only work with Disney. Effort spent in selecting appropriate contacts is a good use of your time, and the Internet has made this job much easier than it used to be.

You might find it useful to start by approaching galleries in your home town: it is easier to gather information about familiar environments; galleries may prefer to support local artists; and of course travel costs will be minimal. Publishers and licensees are less likely to be based in your local area (most market towns boast a gallery or two, but not necessarily a gift manufacturer or publisher), so these will need a bit more research.

You should begin your research process by compiling lists of appropriate businesses. Consider the following source materials:

• specialist art magazines and the arts pages of other publications
• internet searches using the relevant keywords

- local art colleges, adult-education centres and art circles
- art fairs
- trade directories and art-fair catalogues (both online and printed)
- local advertisements and posters
- the Yellow Pages (galleries with one-line advertisements are not necessarily smaller than those with display advertisements; they may just allocate their promotional budgets differently)
- trade fairs. The online-exhibitor lists and printed catalogues can be an invaluable source of publishers and licensees.

Disregard the following:

- businesses specialising in work of a totally different nature to yours
- businesses specialising in specific media, e.g. only handmade prints
- businesses specialising in pictures by one artist only (usually the owner or a member of their family)
- galleries dealing in a very different price range
- craft shops which sell ceramics, jewellery, etc., but no pictures.

Be realistic: there is very little chance of, for example, galleries in the West End of London taking on unknown artists. Consider the artists that galleries represent, and at what stages in their careers these artists appear to be.

It is not usually worth contacting businesses that fall into the above categories on the offchance that they are looking for a change of direction; the odds are against this being the case. There are exceptions; for example, a living equestrian artist might be taken on by a business primarily concerned with antique equestrian art. Think hard before investing time and effort in approaching an 'outsider'; concentrate on those where you have a chance of being accepted.

Remember to thoroughly research companies and organisations before making an approach, perhaps starting with each business's website, in order to ensure that your style is compatible with their own and that their business approach seems sufficiently professional. It is a good idea to visit galleries anonymously too, and try to establish how often exhibitions and displays are changed (professional gallery owners change them regularly). Trade fairs are a good place to assess publishers and licensees; the size and professionalism of their stand is a good indication of their market position.

Personal contacts

You may well have personal contacts in the businesses you wish to approach: friends of members of staff, other artists you know who have worked with them, a friend who works in the business next door, someone who works for a local art magazine, and so on. Such contacts will provide you with valuable background information. Business people are likely to remember artists who come with some kind of recommendation, and will perhaps spend more time looking at their submissions. If you can say 'I'm a friend of so-and-so', you're immediately put into context, you cease being an anonymous stranger, and business people may be reassured, even interested. Also, joining art societies and professional trade associations such as the Fine Art Trade Guild offers valuable networking opportunities.

Telephone contact

Telephone your target business to ask if they are interested in taking on any new artists. The answer will probably be non-committal, and you should not be depressed to hear 'We might be'. The point is to get some kind of positive answer; you can then impress them when submitting your work. It is worth calling just in case there is an unequivocally negative reply, such as 'We are closing down in a month', or 'We are moving exclusively into Russian art and antiques', or 'We represent ten artists and will not want to extend this list for a long time'.

Chapter 4

How businesses find artists

How do businesses find the artists that they work with? There is a range of sources, including:

- personal recommendation
- businesses seeing or reading about artists' work and approaching them
- artists approaching galleries and licensees direct.

When they are just starting out, artists usually have to make direct approaches to businesses, but as their careers progress gallery owners and licensees will start to approach them. The Internet has made it much easier for businesses to track down artists, since many now have their own websites or at least pages on other organisations' sites.

Below are some of the methods that are commonly used to identify artists:

Personal recommendation

This is the most common method. Recommendations from social contacts, friends within the art market, clients, framers, etc. Some businesses find recommendations from their existing artists particularly useful. Art businesses are approached 'cold' by many artists each week, so try to make use of any personal contacts that you can, as this will make your approach stand out.

Direct approach

Many businesses do take on artists who approach them direct, so don't lose heart. Indeed, some rely upon artists doing this, and always examine submissions. The best way to ensure that your submission is taken seriously is to research the business you are targeting and to make your approach as professional as possible (see Chapter 3: 'Selecting the right business' and Chapter 5: 'Making your approach').

Internet searches

If you have your own website, try to establish hypertext links with local art groups and other useful organisations. It's a simple form of promotion to provide art societies to which you belong with JPEGs for posting on the Internet. For example, Fine Art Trade Guild members have their own web pages and are eligible to submit work for the online Guild Artists' Exhibition; both of them can also link to the artist's own website. Above all, maximise every opportunity to publicise your web address.

Degree shows, art society exhibitions and open studios

Art professionals tend to go round degree shows, art-society exhibitions, local arts festivals, open-studio weekends, etc. You should try to be included in these events wherever possible, and in this regard you should also consider joining local and national art circles and societies. It is also a good idea, whenever possible, to attend in person any exhibitions in which your work is featured, so as to optimise the chances of meeting people and developing contacts.

Other businesses

Once artists have sold a high quantity of work at small galleries, they may be approached by the more established ones. Galleries in other parts of the country may be more than happy for their artists also to be taken on by London galleries; this helps develop artists' reputations and drives up prices, while the customer bases are likely to be very different. Licensees may see an artist's work at a gallery then approach the artist either direct or via the gallery.

Competitions and press releases

Art professionals read the art press and notice competition winners, news stories and illustrations. There are large numbers of competitions sponsored by private companies, promotions for artists' materials' suppliers, magazine promotions, etc. Try to seek exposure via the art press wherever possible; it need only take a few minutes to send a group email to art editors on a range of magazines, attaching a JPEG image and a brief news story. Be proactive, create 'news' and 'make noise' to build awareness of your work.

Listings

Art professionals sometimes acquire lists of members from artists' organisations, e.g., the Fine Art Trade Guild, the Federation of British Artists, the Royal Watercolour Society, the Royal Academy Summer Exhibition.

Agents

See Chapter 11: 'Agents'.

Framers

Galleries which also offer a framing service are likely to work for artists. Artists are often attracted to galleries that specialise in hand-finished frames, and these 'framer' galleries often in their turn take on artists and show their work.

Remember to keep in touch with and visit galleries regularly, and be part of the artistic scene in their area. You need to make it as easy as possible for art professionals to find you.

Chapter 5

Making an approach

Artists who are well informed and professional will win the interest and respect of decision-makers, and will certainly have a head start over their competition. While of course the quality and suitability of the art will be the major determining factor, good presentation and an air of professionalism will inspire confidence in an artist's work.

Successful galleries, print-publishing companies and licensees are approached by hundreds of artists every month. Decision makers are busy, and have little time to spend examining new artists' work. You will place yourself ahead of the competition if you make the task of selection as easy as possible.

Even the best artists are rejected by galleries early in their careers, so try not to be downhearted. Try to get something positive from rejection. Ask for feedback about your work, and how it might be developed. Ask for advice on other galleries to contact who might like your work and might have room for it.

Post or email?

It is best to make your initial approach in writing or via email. You are unlikely to be put through to the right person on the telephone, and to arrive unannounced at a gallery or exhibition stand may interrupt

important business; it is not a good idea to start by irritating the people you wish to impress.

The majority of decision-makers want to begin by seeing reproductions of artists' work; they do not have time to talk to all the artists who approach them, and they are experienced at assessing artists' work from reproductions. If they like the reproductions, an appointment will be arranged.

In the days before the Internet and inexpensive desktop printers, artists were advised to approach businesses with a letter, enclosing photographs or 35mm slides. Nowadays many decision-makers prefer to receive emails, as these are quick to open up and look at. The main problem with sending unsolicited emails is that people are becoming increasingly wary about computer viruses, and so may delete any unexpected files. Many people also receive vast quantities of unsolicited emails, many of which they don't bother to open. You can protect yourself to some extent from such treatment by ensuring that your email makes it immediately clear why you are getting in touch.

Ensure that the title, or subject line, of an email sounds specific and plausible. A title such as 'Pictures you might like' sounds suspicious, whereas 'Paintings of Cornwall from David Andrews' sounds more plausible. The first sentence of an email, the one that the person reading it will preview before opening the email, should further reassure them that this is not a virus. Begin with a personal introduction and make the purpose of the email abundantly clear.

When sending an email be sure to make it as personal as possible, so that it doesn't look like a group email that has been sent to a hundred different art businesses. Decision-makers would not be flattered by such a half-hearted overture. Invest as much time and effort in an email approach as you would in a written letter.

The alternative is to make an approach by letter, but nowadays, with the advent of email, you cannot expect any work you send to be returned. Many people find it presumptuous to be asked to return artwork that they didn't request in the first place, even if a stamped addressed envelope is included. You should include disposable colour laser prints; there are many printing and photographic agencies who will manage the colour reproduction and printing of these at a cost that will be much less than making 35mm slides or developing

photographs. If you have the necessary skills, and access to a computer with colour-management software and a reasonable colour printer, you should be able to do this yourself, and thus you'll save yourself some money.

For many years, the norm in the art industry has been to use 35mm slides, and many artists are still reluctant to switch to digital reproductions. Such artists argue that slides provide the best colour fidelity. If you do decide to send slides, you should budget for the likelihood that not all of them will be returned. It is not a good idea initially to send a CD of images, as many decision-makers will not take the time to look at these.

Initial postal or email approaches should contain:

• a short introductory paragraph
• a small selection of reproductions, either JPEGs or colour laser prints
• a relevant CV
• information about the images. In the case of JPEGs this information should be a separate digital file, corresponding with numbers given to each JPEG. In the case of laser prints any information should be included on the same sheet as the image.

It is best not to mention the price of artwork, or a licence in it, in your first communication. Prices vary according to the size and medium of the work, and the status of the artist, so giving prices can mislead. Confusion may arise as to whether the prices quoted are trade or retail ('trade' refers to the price galleries pay), or the suggested price to retail customers.

Where individual artists may fail, artists' co-operatives and societies can be successful in offering galleries group shows. Being identified as part of a group or school can be a strength, and gallery owners may feel confident of hosting a mixed show where they would not have considered a one-person show. The idea of, for example, a show of Artists in Cornwall may catch a gallery owner's imagination, whereas one artist's work may not.

Conveying the right image

Before contacting businesses, you should consider the overall appearance of what you're submitting, which above all must be professional.

Material sent by post must be kept together: it is likely to sit in piles of opened but non-urgent post for a number of days, so reproductions could become detached and lost. Material looks smart in folders, rather than just loose in A4 envelopes. Letters and summaries should be sent flat, not folded. Emailed submissions must be well laid out and in a format, such as a Microsoft Word document or a PDF file, which can be opened easily by all computers and operating systems.

JPEGs, slides and laser copies

The quality of JPEGs, laser copies and photographs is crucial; you should invest in as good a quality as you can afford. This may entail buying your own digital camera, computer and printer or, if your budget and lack of technological skills preclude this, you should out-source this work to the best photographer you can afford.

It will take just a few minutes for any decision-maker to look at quality images and decide whether to consider them further. Poor-quality versions may not be examined at all; they give an inaccurate picture of the artist's work and will not inspire confidence. Good-quality repro is worth the investment; it is on the strength of these images that you are most likely to be given an appointment.

Images must be clearly labelled so that they can be identified as yours. JPEGs must be given your own surname as their file name, and only a picture title if there is room. They should be numbered, and a corresponding list giving the rest of the details should be attached. The relevant information should be printed alongside the image on all laser copies; that way, there is no chance of it becoming detached and lost. One A4 sheet of thumbnail-sized images with captions can be a good idea.

When listing works on paper it is helpful to specify both image and paper sizes. Paintings on canvas can be measured according to 'sight size', meaning the amount of image seen within the frame, or 'canvas size', meaning the total surface of the canvas.

The following information must be given for each image:

- artist's name
- title of the work
- date painted
- medium

- size – metric and imperial; paper and image sizes, or canvas size. Auctioneers and galleries worldwide measure and list pictures height before width. Always adhere to this rule. It is best to put measurements in both metric and imperial: in the UK both systems are used, while Europe is metric and the USA is imperial.

If appropriate the following information can be included:

- note if the reproduction is a detail of a larger picture
- signed and inscribed (if applicable)
- edition size (prints only)
- provenance (e.g. private collection)
- other information (e.g. where exhibited, included in books or magazines, part of a series of works)
- code number (see 'Keeping records' at the end of this chapter)
- indication of the correct way up and, in the case of slides and transparencies, which way round the image should be viewed
- artwork that is no longer available should be marked 'Sold'.

For example:

> Noah Jones
> *Synergy IV*
> Hand-coloured etching on handmade paper
> Edition of 75
> 2005
> Signed and numbered by the artist in pencil
> Image size 8in x 10in (20cm x 25.5cm)
> Paper size 12 x 14 (30cm x 35cm)
> Featured in Art Business Today, April 2004
> Part of Synergy: a series of 15 works
> G30/50

> Holly Jenkins
> Still life with amaryllis
> 2005
> Oil on canvas
> 100cm x 150cm (39in x 60in)

Frames should not generally be included in reproductions, unless they form an integral part of the work. In reproductions the frame tends to overpower the image, partly because it is three-dimensional. If you use particularly high-quality frames this should be stressed elsewhere, as gallery owners will certainly welcome the fact.

It is tempting to send large numbers of reproductions; most artists would feel that their art cannot be illustrated by a few examples. However, decision makers are experienced at assessing the suitability of reproductions, so in most cases it is not worth sending more than about five (it takes time to open each digital file, so most people would not have the time to open more than a few images). Too many reproductions hints at desperation, not professionalism. A well-selected few should entice decision makers to telephone the artist and ask to see more.

It is acceptable to send reproductions of works that have already been sold, as long as they are still representative of your output. To avoid confusion, you should clearly mark these images as such. Reproductions that are boldly marked as 'sold' emphasise your commercial viability.

JPEGs
JPEG is a very flexible format for saving an image (see section entitled Index of artwork, Chapter 1: 'The business side of being an artist'). Small digital files are best for sending to gallery owners with your initial approach, as they are quick to open and can be viewed on a computer screen.

Colour laser copies
The type of paper onto which these are printed makes a difference to the quality and feel of the reproduction. Some artwork would look best on glossy photographic paper, while some might be shown to its best advantage on thick watercolour paper. You should try to use the best quality paper you can afford, as this will flatter the artwork. Some images may need to be adjusted in Photoshop, or a similar program, before they print out satisfactorily.

CV or summary of artistic achievements
Clear layout is essential: any CV must be easy to read. Avoid superfluous information and ensure that descriptions are concise. One

side of an A4 page should be sufficient. Summaries should be amended as your career develops: achievements that are noteworthy when you are just starting out may become irrelevant in the light of later achievements, and summaries should be kept as short as possible. A detailed and complete record of your achievements can be kept in case it needs to be shown at a later stage and also for historic record.

There is no point in including information that is not immediately relevant, e.g., details of previous jobs in different fields. You will not be judged on these; decision-makers are only interested in assessing artistic experience, both aesthetic and commercial.

You should not mention your address, contact numbers or price on your summary, in case it is shown to potential clients or colleagues of the person to whom you are sending it.

Take a look at museum catalogues to see how the careers of famous artists are typically outlined. The following information should be included:

- personal details; name, date and place of birth
- artistic training; courses attended and grades achieved
- relevant teaching positions
- membership of artistic or exhibiting societies
- any other relevant information, e.g., awards, foreign painting tours, success in artistic competitions
- where work has been exhibited, including the exhibition title: solo or mixed; private gallery; art-society annual exhibition; college graduation show, etc. Give dates as well as gallery names and places
- museum catalogues tend to list artists' achievements in chronological order, while some artists make recent achievements prominent by starting with these. The essential point is that the CV is easy to read
- where your work is owned, e.g., private collections in Europe, Japan and the USA; also, public collections in which work is included
- bibliography, e.g., books, magazines and catalogues that have mentioned your work.

The personal approach

Start by deciding to whom the letter or email should be addressed. Check the website or if necessary telephone the business and ask the

decision maker's name. This is generally very straightforward. Do not write to 'Dear Sir/Madam'; this gives an impression of amateur disregard for normal business etiquette. It takes a few seconds to find out the appropriate name.

Letters and emails should differ in content according to the information you have about the business. Say something positive; for example, mention recent local press coverage, a specific exhibition, or how great their stand looked at a recent trade show. Try to make that publisher or gallery feel that they are the only business you want to work with.

Be brief and to the point; don't just repeat what is laid out in the CV. You need think creatively: what should be said that is not in your summary and not expressed by your reproductions? There is no point in starting, 'I am an artist working in the Impressionist style'; it is obvious that you are an artist, and your style is best understood by a glance at your reproductions.

The following information should be included:

- you should make it clear that you have researched and visited the business
- mention any personal recommendations or common acquaintances
- state clearly why representation is being sought, e.g., why previous arrangements have been terminated or are insufficient
- outline the suitability of your work to the particular gallery.

You should not end with 'I look forward to hearing from you': be positive and indicate clearly what your next move will be.

Follow-up telephone calls

The length of time it takes decision-makers to examine your submissions will vary enormously. If you state in your letter or email that you will be in touch in two weeks, and you have not heard anything by that time, then you must follow up. It is a good idea to start by checking that packages or emails have been received.

Polite calls are likely to speed things up a bit. Decision-makers may contact you as soon as they have opened your post, but don't be downhearted if this is not the case; it may be that they are away, or in

the middle of a busy period. You need to call to find out.

Always be polite. If staff get to like you on a personal level, they are more likely to prompt decision-makers to look at your reproductions, or to put them on the top of the right person's in-tray.

Robert Millar
25 Church Road, Shepherd's Bush, London W12 4LP
Telefax: 020 7603 9797
robertmillar@yahoo.com
www.robertmillar.co.uk

25th February 2004

Mr V Downes
Ledbury Gallery
126 Portobello Road
London W11 2RB

Dear Mr Downes

I particularly enjoyed your recent show 'The Art of the Human Form'. I would be pleased if you would consider including some of my work in your next group show, with a view to a solo show at a later date. Your gallery has been strongly recommended to me by Mandy Donaldson.

I am currently represented by two UK galleries (for details see my CV), but these are not in close proximity to the Ledbury Gallery. The owners of both galleries know that I am contacting you.

Attached are my CV and some reproductions of my work. I would be happy to attend a meeting at your convenience. I will contact you in two weeks' time to discuss this further.

Yours sincerely

R. Millar

Robert Millar

Meetings with decision-makers

If your submissions impress the right people they are likely to ask you to a meeting at their offices. They are most unlikely to make final decisions before meeting you and seeing the originals. You should take the following to meetings:

- examples of your original work
- your portfolio (if you work on paper, this should include originals)
- laser prints showing a wider selection of work (optional).

You should also find out whether the decision-maker is interested in particular media or subjects ('Portfolios' and 'Choices of original work' are discussed below). You are trying to develop a relationship with someone, so you'll need to show just as much interest in their business as you hope they will in you. Try to avoid appearing 'difficult', but at the same time try not to appear too eager. Explain why you would like to work with a particular company. Both parties need to assess whether they will be able to work together, to decide that they like and respect each other, and to feel they can trust each other.

The following subjects should be discussed:

- standard arrangements with artists, such as commission rates and payment terms
- the extent of the business's publicity campaigns and promotional efforts.

These points are covered in detail in Chapter 7: 'Terms and conditions between artists and galleries'.

You should compile a list of the questions you wish to ask. This is a particularly good idea if you are nervous. It will save time, and most decision-makers will be impressed by your organisation and sincerity.

It is every business person's nightmare to have clients waiting for commissions, or major trade fairs looming and no sign of the promised pictures. It may seem a prejudiced view of artistic temperament to suggest that artists are often unreliable, but it is a situation with which many art businesses are all too familiar. The interviewer is likely to ask you questions about your output in order to assess whether this

problem is likely to arise. They may ask the following:

- how long on average it takes you to produce a picture (the way in which you answer the question will tell them how well you understand the importance of deadlines)
- the number of completed works ready for sale in your studio
- whether you have a long backlog of commissions to complete
- details of any previous arrangements you have had with galleries and licensees.

You should make a point of stressing your reliability and professionalism. Don't feel pressed into making decisions there and then; if in doubt, thank them and say you'll be in touch in a few days.

Don't be despondent if the initial requirement is modest; this is quite normal. Businesses may want to see how your works are received before requesting more. New artists may not appear in a business's publicity material whilst they are effectively 'on trial'. This can be disappointing, but caution makes commercial sense.

Gallery owners and licensees may make appointments to visit your studio before committing themselves to any work. Needless to say, you should see that your studio looks productive and professional, and not too chaotic. Make sure that your best work is on display, that a range of work is easily accessible, and that there is an easel or similar on which to show your work.

Portfolios

The standard portfolio is black with zip-up sides and a handle at the top; these are available from artists' materials shops. If your budget will stretch far enough, a custom-made portfolio gives a good impression, though it is certainly not essential.

Presentation is important here as elsewhere; any portfolio should be smart and well presented. If your work is decorative, why not use your portfolio to express this? It need not be expensive; creativity and imagination are key. People may not spend long looking at your portfolio, so first impressions are important.

The contents of the portfolio should be clearly labelled, or numbered with a corresponding list of contents. Some artists keep their portfolios for a range of original work and have separate press books.

Others include the following:
• press cuttings
• certificates for awards or courses completed
• pages or covers of catalogues
• private-view invitations
• exhibition posters (reduced in size if necessary)
• greetings cards, prints, etc.
• anything else that illustrates artistic styles and achievements
• a well-presented set of reproductions of original work.

Choices of original work

You should show pieces that are representative of your work as a whole. Consider your selection carefully: a few well-chosen pictures will create the most professional impression. If the meeting goes well you can arrange to take in more pictures at a later date, or for the contact to visit your studio.

Framed or unframed?

It will probably be easier to take in unframed work, as this is more portable. If, however, you hand-finish and decorate your own frames, and these are an integral part of your pictures, you must of course take framed works. The possible drawback of taking unframed works is the role of frames in enhancing pictures; unframed pictures may be seen at a disadvantage. However, art professionals are skilled at examining pictures, so this is generally not a problem.

It can be a sensible compromise to surround works on paper by window-mounts: these protect and complement the pictures, look smart and are easier to carry. You may spend money having a picture framed only to find that the first thing a gallery owner does is advise replacing the frame.

Picture frames have two roles: to protect the artwork and to enhance it. Framing and glazing protect artwork on paper from humidity, insects and air pollutants (and UV light if glazing with a filter is used).

Possibly the greatest threat to the longevity of artwork is the quality of materials used in framing; if these are poor, irretrievable damage can result. You should discuss 'conservation framing' with your framers; this need only add around 10 % to the bill. For further information on

framing styles, materials and techniques, contact the Fine Art Trade Guild and ask for their book list.remember that poor-quality framing gives an amateur impression and can greatly detract from the impact of your artwork. It is important to take the time to choose framing that will complement your work, reinforce its aura of quality, but not overpower it.

Some guidelines for artists when selecting frames:

Artists must ensure that no key elements of their work, particularly their signature, will be concealed by a frame or mount. Paintings should be signed at least 15mm into the canvas or paper.

Oils and acrylics on canvas and panel
Talk to other artists to find an appropriate framer who understands your kind of work and has the facilities to deal with it. Remember that in some galleries canvases are left unframed: this is done for aesthetic reasons as well as cost.

No glass or acrylic glazing is needed for varnished oils and acrylics, as the surface is water-resistant and can be cleaned with a damp cloth. Glazing can reduce the clarity of the image, especially where thick paint has been used, and it will damage the paint if allowed to touch it.

Frames can be of two types: either a box (where the moulding does not touch the side of the stretcher but comes from the back and is level with the surface of the canvas or board) or a traditional overlapping moulding can be used. The latter need not look old-fashioned if a contemporary surface finish is chosen, such as a black or coloured stain.

Watercolours and other works on paper
Glazing is required to protect the paper. This must not touch the artwork, so a rectangular window-mount is normally placed on top to create a gap between the image and the glass. Contemporary work is enhanced by being displayed in a box frame, where the glass is suspended above the image by the use of fillets or spacers; these are placed between the mount, upon which the work is floating, and the glass.

The best advice in choosing frames is to play it simple unless you are

If you have worked on good-quality acid-free art paper, then the framer should use conservation or cotton-museum mount board. Cotton-museum or conservation board costs more, but will help to preserve your artwork over a long period of time. Conservation board is available in a wide range of colours and finishes, though not as many as standard mount board. A professional framer, such as someone who has qualified as a Guild Commended Framer (GCF), will be able to explain the advantages of conservation framing materials and techniques.

A guide to colour is that the window-mount should bring out the best in the lighter areas of the work; thus, if the lightest colours are mid-tones then a white or cream window-mount may be too bright. The colour of the frame works best when seen in relation to the dark paint tones; thus, if there is no black in the work then a black frame would be too dark.

Keeping records

It is very important to keep clear records of the names of businesses that have been approached, with notes as to how they reacted to the work and the stage that negotiations may have reached. Make notes about email exchanges, dates that letters were sent, and so on (See Chapter 1: 'The business side of being an artist').

Chapter 6

Pricing original work

Galleries cannot generally afford the capital outlay of buying work outright, and even if they could it is not sensible to tie up funds unnecessarily. There is less risk and more flexibility in taking work on a sale-or-return basis, and these are the terms on which most galleries will take your artwork.

Some gallery owners are in a financial position to buy one or two pieces from artists in order to help them out, but such gestures are more likely to be special favours than the pattern of regular business dealings. Gallery owners may buy outright at the less expensive end of the market; for instance, they may buy selections of handmade prints from artists' agents. Once you are established, and there is competition for your work, you may be able to persuade gallery owners to buy it outright, though it is extremely unlikely that any gallery owner would buy a whole exhibition. Some artists, however, do offer galleries their work at a sale-or-return price and also a lower price for an outright purchase.

There is more to pricing pictures than just assessing their aesthetic qualities: an artist's reputation is likely to have a great effect on the value of a particular piece. It is not sensible to price pictures by comparison with similar works in other galleries. If an artist has spent many years developing a reputation, the price of their work will be

correspondingly high. The work of unknown artists may be similar in style, but the prices the market will bear will be very different. The market for all commodities is affected by the confidence of potential buyers, and collectors are influenced by an artist's past successes and prices. Unknown artists do not have impressive reputations and price histories to inspire collectors' confidence. In addition to its visual appearance, critical acclaim, the fame of the artist, the stage of the artist's career at which the picture was painted, prices fetched by previous works, and other factors all affect the price.

Pricing for artists

Start by working out the following:

- direct costs (e.g., materials, tools, canvas, paints, framing)
- overheads (e.g., rent, heat and light, insurance, telephone, administration costs)
- the time it takes, on average, to create and finish each piece.

At the beginning of your career, it is important to be aware of these figures; even if they are not systematically reflected in the price of your work, they represent a sum above which prices need to rise, a baseline figure. If you have kept a record of costs and labour you will be able to assess how prices are progressing, and thus you'll have a basis from which to start negotiating. You may be faced with a difficult decision over whether or not to let galleries show your work at practically no profit. This dilemma will be easier to resolve if you have a clear idea of your overheads.

Gallery owners will almost certainly have better ideas on pricing than the artists they represent: being specialists in retailing, they know the market. Gallery owners will generally start by asking you the range of prices you want for your work, and then offer guidance as to whether this is too much or too little. In doing this they will take into account the prices that your work has fetched previously, and they will also look at the quality and location of the galleries that have sold it.

It is important to respect gallery owners' knowledge of what kind of work will sell. It is in your interests for any sales of your work to be as profitable as possible, so don't be put off by any suggestions they make. Gallery owners cannot afford to work with artists who have no understanding of market forces and business overheads.

Commission rates

It is important that you understand fully the basis on which galleries are taking your commissions. You will not be able to negotiate fair deals for your work if you don't make an effort to understand these terms and conditions, and if you don't understand them you may be inclined to take the generally unfair view that gallery owners are exploiting you. Relationships based on misunderstandings are unlikely to flourish.

The effort, expertise and financial outlay that gallery owners put into selling artists' work is far too often underestimated. It is common to hear people remarking in tones of outrage that such-and-such a gallery takes 50% of the sale price for an artist's work, when it is the artist who actually creates the pictures, and all galleries do is to hang them on their walls. There are substantial costs in running galleries and mounting exhibitions, and immense effort and creativity goes into selling pictures in a competitive market. Artists are not paying commissions to gallery owners just for the hire of wall space; they are buying into the galleries' hard-earned reputations and the loyalty and trust of their clientele.

Gallery owners are not only competing with other gallery owners; they are also in competition with restaurants, holidays and other leisure activities for people's disposable income. As the marketing and promotion programmes of these competitors develop, so must the gallery owners', and this takes time, money and imagination.

Commission rates vary greatly. The factors affecting them are:

• the artist's reputation
• the gallery's reputation
• the division of costs between gallery and artist
• the extent of marketing and promotions.

In addition to a gallery's day-to-day overheads (heat and light, wages, rent, administration, etc.) there are direct costs involved in selling an artist's work. These generally include:

• display/framing
• printing catalogues and mailshots
• website updates
• postage

- advertising
- private views (invitations, drinks, food, flowers, security guards, etc.)
- photography
- transport and delivery of works to clients
- insurance
- VAT.

These direct costs are taken care of in one of the following ways:

- they are split between artist and gallery
- a proportion of such costs is deducted from the proceeds of an artist's sales
- the gallery pays them all, but takes an additional percentage of commission to reflect the extra burden.

It is common for artists to pay for framing. If in addition to framing you are asked to pay, for example, 50% of printing and private-view costs, you should consider both the prices that the gallery is asking and the commission it takes. If the gallery is only taking, for example, a 30% commission and is confident of achieving high prices and brisk sales, then this may represent a good deal.

It is thus misleading to say, for example, that galleries generally keep 50% of sales proceeds. This statement needs qualifying. It makes a difference which party paid for framing and publicity costs, and the prices the gallery asks and the volume of sales it turns over are also factors. If you provide unframed pictures and the gallery pays for the framing out of its 50% cut, then you are perhaps 10% better off (and the gallery 10% worse off) than you would be if framing costs had been equally shared.

If a gallery pays all costs and the artist is not well known, then the gallery is likely to keep between 40% and 50% of sales proceeds, excluding VAT. If the artist provides ready-framed pictures and contributes to publicity costs, then the figure may drop to 30%.

Gallery/framing shops sometimes take fees as low as 20% because:

- they don't have expertise in promoting artists (e.g. they are primarily a picture-framing shop)
- an artist's reputation will not be greatly enhanced by association with such galleries

- sales may be slow and prices modest
- original art is seen primarily as a vehicle for increasing framing sales.

If a professional gallery charges low commission rates it may be because:

- The gallery does not intend to incur promotional costs (advertising, catalogue, private view, etc.). In this case, you should seek reassurance that the gallery is going to make an effort to sell your work. It is not advantageous for an artist to have a gallery holding their work in a basement on the off chance that someone may come in and ask for something of this type.
- It may be that there are costs which have not yet been discussed.

Agreed fees per picture

Gallery owners generally operate on a commission basis. You should feel sufficiently confident in the sales skills of most gallery owners to prefer commissions to set fees; on this footing, it is in any gallery owner's own interests to get the best possible price for your work.

Discounts

It should be decided in advance how discounts are to be handled. If a client is given a 10% discount, it is usual for both the artist and the gallery to lower their own percentages to accommodate the discount. A gallery owner who feels it would be sensible to offer bigger discounts is likely to want to discuss it with the artist before agreeing a price with a client. If the artist will not take less than a certain amount for a particular work, the gallery owner then has to decide whether to forgo sales or else accept a lower percentage for the gallery.

Instalments

Some gallery owners will accept payment in instalments. If they know clients well, they may allow them to take work away in advance, though it is more common for galleries to retain work until all monies have been paid. What a particular artist is paid varies according to the value of the work and the length of time over which the instalments are spread. If the work is of low value and full payment will be received in a matter of weeks, it is likely that artists will be paid at the close of the deal; it would not be worth the bank charges and

administrative costs involved in making multiple payments. In the case of a high-value deal spread over a longer time, artists might expect to receive interim payments.

Advances

In today's marketplace it is becoming rare for an artist to be offered advance payment, though it does happens at the high end of the market. Advances are made to provide an artist with a more regular income, not just a high income at the time of the show, thus leaving them free to concentrate on their art without having to worry about earning a living from other sources (e.g. from teaching). Advances are usually given so that artists can work towards specific exhibitions, but are usually only offered to those artists who are much in demand or have a long-established relationship with a gallery.

VAT

It is essential that you understand the basics of VAT. Otherwise, you may find that the payments you receive for your pictures are up to 17.5% less than you expected, not because the gallery has misled you, but because you have failed to understand the rudiments of retailing.

Most artists are not registered for VAT; they do not have a high enough turnover (the present level is set at £58,000 and it is usually increased each year). However, the VAT registration of galleries and their normal practice of taking on artists' works on a sale-or-return basis does mean that care is needed so that VAT is paid only on the difference between the price at which the gallery sells and what the artist actually gets paid for the work. Galleries will often ask for a letter or statement to confirm an artist's non-VAT registration status; this is to help the gallery calculate its own VAT liability correctly and, if both are VAT registered, the right amount of tax is accounted for by each of them. On the other hand, to make things simpler, some galleries just charge VAT at 17.5% to the client on top of the sale price. This ensures that no VAT has to be absorbed either by the artist or the gallery.

Chapter 7

Terms and conditions between artists and galleries

Consignment notes

It is essential that consignment notes (often called SOR notes) are given when you leave work with galleries. Otherwise your ownership of your work cannot be proved and your interests cannot be protected. Consignment notes may be handwritten in books with carbon-copy pages or printed in a standard format from a gallery's computers. These notes represent proof that a gallery has an artist's work in its possession, but that the work remains the artist's property. Both artist and gallery owner should sign these documents, and both parties must retain copies. Consignment notes differ from contracts of business in that they refer to the actual possession of specific pictures.

Consignment notes represent proof of ownership in the event of an insurance claim, and they go a long way towards preventing financial disputes. Trust between artist and gallery owner can only count for so much in a dispute. In the unfortunate event of a gallery going into liquidation a consignment note proves to the liquidator that the art-works in question are not part of the gallery's assets, or that money is owed to the artist for sold paintings.

The following information should be clearly documented on consignment notes:

- name and address of the artist
- name and address of the gallery
- dates on which pictures were left
- titles, media and sizes of pictures
- whether frames were included
- the sum of money that should be paid to artists if framed or unframed pictures sell, and whether this is the figure before or after VAT has been deducted
- the length of time for which galleries are to hold work if it does not sell
- confirmation that work is insured while with galleries, whether in transit, at clients' premises, on exhibition stands, etc., and at what value
- notes to the effect that works remain the artist's property until they have been sold and paid for in full
- both the artist's and the gallery owner's signatures
- the consignment note must make the identity of the artwork clear, particularly if you produce many works that look similar. This avoids confusion and, in the unlikely event of the gallery going into liquidation, makes it much easier to prove ownership. For example, the same reference number could appear on the artwork and on the consignment note.

Contracts

Contracts are not essential, but consignment notes are. Certain gallery owners, even those at the top of the market, are likely to say that contracts are meaningless. Artists will find that a lot of galleries do not have them. Many artists and gallery owners feel that 'small print' and contracts are unduly restrictive; that it is more important to ensure there is mutual understanding and that both parties have understood things in the same way. Where both parties agree that a written contact should be signed, this need not be long or worded in legalese. If either party is unhappy about any aspect they should seek professional legal advice.

It is important that both parties fully understand their contracts. Artists too often disregard them as bureaucratic nonsense and then feel that gallery owners have 'ripped them off' when they receive less in

payment than they expected. This is not fair. You must take the time to understand contracts and raise objections before agreeing to them. You cannot sensibly claim to have been 'ripped off' if you have simply misunderstood your entitlements.

Contracts are likely to include information on:

- pricing and payment terms
- exclusivity, the duration of the arrangement, and terms for commissions
- access to an artist's client lists
- the timescale for the delivery of pictures and a description of these
- division of the costs of framing and promotion.

Payment terms

A common complaint from artists is the length of time some galleries take to pay; some don't bother to pay until the artist chases them or turns up to collect their work. As a rule you should certainly expect to be paid within 28 days of the gallery being paid. You should come to an agreement with the gallery as to whether you will be paid a certain number of days after exhibitions close, whether you will be paid on various dates, or as each piece sells. You should also discuss discounts and payment in instalments, as outlined in Chapter 6: 'Pricing original work'.

In the main, artists only know that pictures have sold when gallery owners inform them (they generally feel uncomfortable phoning up to ask how sales are progressing). Moreover, they sometimes complain that gallery owners do not let them know when pictures have sold deliberately in order to delay paying them. If the relationship between artist and gallery is professionally managed this is less likely to occur. As your career progresses, you may feel confident enough to drop galleries that do not keep you informed and take longer to pay up than is reasonable.

Exclusivity

If you have developed a relationship with a gallery, you should always discuss with that gallery any invitations to exhibit elsewhere, and vice versa. Only at the top end of the market are gallery owners likely to restrict an artist's trade with other galleries. Most gallery owners

cannot afford the financial tie of paying retainers to artists, and in today's unpredictable market this kind of long-term commitment is no longer appropriate. In the past it was common for galleries to pay retainers to artists – almost annual salaries – and artists were thus obliged to provide a specified minimum number of works and not to show work elsewhere. Nowadays most professional artists exhibit at a number of different galleries.

Most galleries will expect you to keep them informed as to who else you are supplying. Obviously, it is in your own interests to do this; it is generally assumed that an artist does not abuse a gallery owner's trust by showing work 'behind their back' at rival galleries. Some gallery owners actively encourage their artists to exhibit elsewhere, as this develops their reputations. However, they may advise artists against exhibiting with particular galleries at certain times; and a gallery owner acting as an artist's main representative will expect to get first option on that artist's work.

Sometimes it will be agreed that an artist is not allowed to supply other galleries within, say, a 50-mile radius. Some galleries may also have exclusive rights to sell only particular types of work, e.g., paintings in watercolours or of racing subjects, allowing artists to sell other types of work elsewhere.

It is important to clarify whether the arrangement you have with a gallery allows you to sell direct to private customers within the geographical area that is the gallery's agreed territory. The Internet means that artists with their own websites, or with pages on other sites, are more likely to be approached direct by private customers than in the past. Sometimes galleries are entitled to commissions on private sales, or perhaps reduced commissions, or sometimes commissions are not payable on certain types of private sale (e.g., sales to collectors who the artist knew before their current involvement with the gallery). You should reach an agreement over the prices at which you sell your work to private customers, to avoid the potentially embarrassing problem of your own website (or any other forum through which you sell work) undercutting your own gallery.

When selecting artists, gallery owners take care to establish which other galleries represent them. If a gallery takes an expensive stand at an art fair the last thing they want is to discover, on setting-up day, that the stand opposite is prominently displaying the same artist's

work. Most gallery owners are also none too happy when customers comment that they have seen that artist's work in another gallery. It's in your interests, if you are represented by more than one gallery, that the various gallery owners know about each other; that way they can discuss issues such as stands at national art fairs, and they can also keep an eye on each other's pricing.

At the top end of the market, gallery owners often like to handle their artists worldwide; many prefer to organise overseas exhibitions themselves than see their artists go to foreign galleries. Also at the top end, gallery owners sometimes arrange exhibitions for their artists at other galleries so as to develop their reputations, though this is only likely to happen if artist and gallery have worked together successfully for some time. The gallery may take, for example, 10% or 20% commission on any works sold, leaving the host gallery with 30% or 40% and the artist 40% or 50%. Exhibitions such as these are therefore not very profitable in the short term, but they do develop an artist's reputation.

Some galleries pay their best-selling artists a monthly sum and then work out a precise schedule of payments every few months. These gallery owners like to secure their artists' loyalty by paying at the same time each month, and making an effort to offer some level of security. This regular income is different from a 'retainer' in that it is not part of a legally defined exclusive relationship.

Client lists

Galleries nearly always ask artists to supply client lists, sometimes emphasising that these names will only be used in promoting that artist's work. Good client lists are important bargaining tools for artists, and go a long way towards encouraging gallery owners to show their work. In today's market, artists are expected to help their galleries to help them, i.e., to canvass new customers themselves and provide details of interested parties they have met socially, not just rely on galleries to do it all. Artists who invite large numbers of their non-art-buying friends (particularly students) to private views are unpopular with gallery owners. The presence of too many people at private views can be a disincentive to sales.

It is important that you keep records of clients' names and addresses, dates of purchases, where work was sold, prices paid, etc. You should invite clients to exhibitions, keep them up to date with developments in your work, and try to nurture good working relationships with them.

An artist's active involvement in the process of showing and selling work is invaluable: it maximises sales and plays an important part in ensuring that artist and gallery owner develop a productive and professional partnership. A commitment to attending private views, signings, 'meet the artist' events, etc., can form part of the agreement between artist and gallery; these undertakings normally enhance sales, since they appeal to the public taste for celebrity.

Studio sales

If a client goes direct to an artist, the artist's gallery owner may still expect to receive a commission. If an artist is represented by a gallery on a long-term basis, it is likely that the gallery has invested a lot of time, effort and money in developing the artist's reputation, so it is reasonable to want a commission for any work sold in this way: without the gallery's work on the artist's behalf, clients may not have known about the artist or may not have wanted to own a piece of their work. A gallery will specify its own percentage for studio sales, which will vary depending upon how the first contact between artist and client was made. If a good gallery client approaches an artist direct, the artist has an obligation to refuse to deal with them other than through their gallery.

If an artist is only working with a gallery on a single exhibition, the gallery might still expect to take a cut of any studio sales received while the exhibition is on display: clients who buy work during this period are likely to have seen the artist's work at the gallery's exhibition and then to have gone directly to the artist with the specific intention of cutting out the gallery. It is hard for a gallery owner to be sure when this is happening, particularly in the days of the Internet, but it is in an artist's interests to develop a relationship of trust with any gallery that handles their work.

Commissions for future work

You should always agree terms for commissions, such as portraits and other bespoke pictures.

Artists commonly complain that gallery owners accept deposits from clients but do not pay even the cost of materials until the commission is complete. Gallery owners, in turn, sometimes feel that if they pay artists too much in advance there will not be enough incentive for them to finish commissions on time. There is always a chance that clients will reject the work they have commissioned, so some gallery owners prefer not to pay an artist until the deal is complete and the client has taken the work. The best way of ensuring that a client likes the finished piece is to show them a number of sketches as the work progresses. Some gallery owners will not even take commissions, just because they can be so problematic. Others will only accept commissions on behalf of artists whom they know to be reliable.

Clients' deposits vary, but they rarely exceed 50%. Some gallery owners will only accept commissions from clients if they feel confident about selling the work through the gallery in the event that the client rejects it. For example, they might accept commissions for local scenes, for which there might be a healthy local market, but not for portraits.

Gallery owners will probably not take deposits for resaleable work. Some gallery owners take the same percentage for commissions as for gallery stock, while others take a smaller percentage. In any case, most artists will charge more for portraits than for gallery stock, so gallery owners may take a smaller commission with a view to receiving an amount equivalent to their normal percentage for gallery stock. It is likely that a gallery owner will take the usual percentage for a commission that is similar in style to gallery stock – for example, a client wants something in slightly different colours and five inches larger – but may also negotiate a lower rate with the same artist for a commission which is very different, such as a portrait.

Guaranteed sales

It is almost unheard of for galleries to guarantee that a certain percentage of an artist's work will sell, or to offer to underwrite the artist's risks by buying a certain number of works themselves. If nothing sells and the artist has paid for the cost of framing, as is usual,

the artist still has to bear this cost; this may seem unfair, but the gallery will have incurred promotional costs and wasted overheads. Some galleries, usually small ones, charge artists a fee of between £50 and £300 if nothing sells. Others expect artists to pay a percentage of promotional costs if only pictures totalling less than a certain amount are sold. This is certainly something you will need to clarify in advance.

An artist's influence

Most artists don't have the right to say which other artists are included in mixed exhibitions; nor can they expect to tell gallery owners how exhibitions should be hung, how catalogues should be laid out, etc. However, some gallery owners may value their input.

Insurance

An artist's work is usually insured by the gallery once it has been consigned to them.

Many artists have no idea whether or not their work is insured while with a gallery, and on what basis they will be reimbursed in the event of damage or loss. In this regard, it is obviously sensible to protect your interests by enquiring about a gallery's insurance. Normally, insurance is on an 'all risks' basis, to cover damage and loss while in transit, on loan to clients, at exhibitions, while being framed and in the gallery. In the event of damage or loss you should expect to be paid the equivalent of your percentage of sales proceeds projected for those works. Some galleries insure their artists' work up to certain values, after which they have to pay additional premiums; the division of these extra costs is negotiated with the artists.

How long do galleries retain their artists' work?

Galleries that have constantly changing exhibition programmes are likely to ask artists to collect their work within a few days of the exhibition being taken down. Other galleries like to retain some work for around six months; this enables them to rotate the works on show, take pictures to clients' houses and offices, and allows for follow-on response to a show.

Some galleries will ask to keep unsold works from solo exhibitions for use in forthcoming mixed exhibitions. It is useful for both parties if this time period is clearly specified. Otherwise, unsold work may

gradually find its way to the back of a gallery's storeroom and be forgotten. Time restrictions are dependent upon how many works a gallery has retained in the first place; this is more of an issue if forty works have been borrowed, and not just one or two. You should remember that your early work may become highly sought-after as your career progresses.

How long do artists and galleries work together?

Until artists are well known, the length of time that they spend with particular galleries is likely to be informally arranged. Gallery owners will let their artists know when pictures sell and will ask for a few more. Once pictures have been sold for a while on this informal basis, exhibitions may be arranged, either mixed or solo (some galleries offer artists solo exhibitions straight away). Exhibitions may be arranged a few months, or even one or two years, in advance. This length of time will depend upon a gallery's schedules, how quickly an artist works, and whether that artist has work ready to sell. Most galleries are run from exhibition to exhibition: if a show goes particularly well then another will be planned for the year after next. It is usual for galleries to exhibit their artists every other year to allow them time to build up a body of work (exhibitions of prints may be held more often, as with multiple works it is clearly easier to quickly build up enough work to merit an exhibition).

At the top end of the market, artists can be committed to particular galleries for years, with galleries negotiating the right to deal in their artists' works after death. Remember that a gallery owner needs time to develop an artist's reputation by becoming associated with a particular artist's work. It is therefore in your own best interests to have strong working relationships with gallery owners.

There are, however, negative aspects of long-term arrangements: artists can feel they prevent the natural development of their work, gallery owners can find themselves committed to working with artists who have 'gone stale'. Contracts should thus always include a provision for terminating the agreement. This would normally cover circumstances allowing either party to break off relations, along with the number of days' written notice required by either party for that outcome. Provisions are also made for settling accounts in the case of death or bankruptcy. Contracts often state that neither party can terminate an agreement less than a certain number of weeks before an exhibition's scheduled start.

Copyright

You should have a clear understanding of the rudiments of copyright law. See Chapter 12: 'Copyright and reproduction rights'.

Framing

It is usual for artists to pay for framing costs. However, this is open to negotiation, and as artists become better known they can make greater demands on galleries. Artists often cannot afford to pay for framing before an exhibition (framing 50 oil paintings at a cost of £150 per frame incurs a bill of £7,500), so galleries may fund this themselves and deduct the cost from sales proceeds. Some gallery owners will not pay for framing at all, even by deducting the cost from the sales proceeds; they cannot afford it any more than the artist can. Galleries also generally reserve the right to reject pictures that have not been adequately framed, where the artist has been responsible for this function, so there needs to be consultation between the two parties. Gallery owners are likely to respect their artists' views on framing, and would probably only reject substandard or cheap-looking frames. The worst scenario is that nothing sells and artists are left with large framing bills as well as the problem of storing the framed work.

Gallery owners are often heard to complain about the standards to which artists frame their work. While the cost of framing often results in some aesthetic compromises, you should ensure that frames are structurally sound and are not actually jeopardising the longevity of your artwork. For example, masking tape will only last for a short time so should not be used to attach artwork, and acid burn from hardboard will cause paper to deteriorate if a protective layer is not placed between artwork and backing. You would be well advised to talk to a professional framer about conservation framing materials and techniques.

It is tempting to save money by reusing old frames. This is not a good idea if the frame is dated, damaged or in a very different style to the picture being framed. Such a frame is not likely to enhance the artwork, nor impress art buyers and gallery owners. Shoddy framing can damage an artist's reputation and deter people from buying the work. Good-quality framing enhances a picture, while poor quality and inappropriate framing detracts from its appeal. A good frame can help sell a work.

The Fine Art Trade Guild puts framers through rigorous tests, and awards Guild Commended Framer (GCF) status to those that pass. Look at the Guild's website to find a qualified local framer.

Some artists prefer to do their own framing, partly for aesthetic reasons and partly to keep the costs down. Since inadequate framing can do so much damage, you should consider having proper training before attempting to frame any of your own work. Look at the Guild website (www.fineart.co.uk) for a list of training courses.

Galleries will sometimes buy standard-sized frames from an artist at the end of an exhibition, or else they are prepared to buy a number of frames which will then be dismantled and reused. If a gallery earns a large percentage of its revenue from framing, the gallery owner may not want to see anyone else's frames in the gallery, so will insist on arranging and financing the framing in-house; this extra cost will inevitably be reflected in the gallery's commission. Some galleries frame their artists' work themselves and then price the frames separately; unsold frames are reused, and the gallery's commission is taken net of framing costs. A gallery that also does the framing is likely to offer the artist trade price for framing the work.

An artist can feel unfairly treated being asked to pay for framing, as the gallery's commission is taken on the total sales price, including framing; artists often feel it would be fairer if commission was worked out net of framing. You should make sure to mention this point when negotiating commission rates.

Artists who work to standard sizes sometimes employ reusable display frames. The work is thus sold unframed, or customers order frames from the gallery, and new pictures are put in the display frames when the pictures sell. A gallery owner may be impressed if you have a set of these – they are time-saving – but there is also the chance that the frames will not be to the gallery owner's taste. However, sizeable reductions for works that are sold unframed can clinch sales; they can be marvellous incentives, as they give clients the sense that they are picking up a bargain. Good-quality frames in standard sizes can be used again and again.

Promotion and promotional costs

In any discussions with galleries, make sure it is clear which party will finance catalogues, private views, photography, etc. The division of costs varies enormously; it is reflected in commission rates, and is affected by the reputation of both artist and gallery. Some galleries state that they will finance certain items, but that if an artist requires, say, a more elaborate catalogue or additional advertising, then the artist must fund these extra costs out of their own pocket, or else a division of costs will be negotiated. A well-produced catalogue will be of great value to an artist in the future promotion of their work. Catalogues constitute a valuable part of any artist's portfolio, so it's always worth carefully considering opportunities to part-fund their production.

Some galleries will not ask for contributions from their best-selling artists unless they feel that they are taking risks. Those galleries that take the highest percentage of commission, e.g., 50% or more, are likely to pay all the promotional costs. Galleries that take around 30% commission are most likely to ask the artist to contribute.

Many galleries no longer produce expensive promotional material such as catalogues. If they do produce them they are likely to expect contributions from the artist. Sometimes an artist is able to acquire corporate sponsorship, or else a grant, to cover catalogue production; an artist who approaches a gallery with a ready-made catalogue is likely to be well received.

With any gallery you deal with, make sure to discuss the extent to which the gallery will promote your work. Promoting exhibitions can cost relatively little, e.g. 150 invitations, a couple of posters and photocopied price lists, or many thousands of pounds, e.g., full-colour catalogues, mailshots of 10,000 and PR consultants.

Keep abreast of the gallery owner's efforts and expenses in promoting your work; this will help you decide if commission rates seem fair, and it will enable you both to work effectively together to promote your exhibitions. Galleries that charge a higher commission should work harder for their artists, invest more in promotion and obtain higher prices for the work.

Gallery owners often complain that artists are not prepared to help promote and sell their own work. It is in an artist's best interests to make an effort to attend private views and to be enthusiastic about meeting the gallery's most important clients. The artist should make suggestions as to how exhibitions and private views could be promoted, and should let the gallery owner know about positive conversations with clients at private views (so that the gallery owner can follow these up).

Transport

It is normal for an artist to finance the delivery of their work to the gallery and the collection of any unsold work. As early as possible, you should decide whether you, the gallery or the client will fund the delivery to the client of work that has been sold, particularly very large paintings. The following costs may be incurred: delivery services, picture-hanging services, packing, insurance, and transportation overseas. Packing and shipping abroad is likely to be paid by the client. Other costs can either be split between you and the gallery or they can be the responsibility of one party alone.

Bankruptcy

If a gallery goes into liquidation while still in possession of your work, it will be a big advantage if you have consignment notes clearly identifying your work and confirming that all work thus covered is your property until and unless it has been paid for in full. You should inform the liquidators as soon as possible that you own the work, so that it is not sold as part of the gallery's assets. If a gallery owes you money, you must make certain to be included on the list of creditors within one month if you want to be paid, so it is important to stay in close contact with anyone holding your work. Communication is key; you are most likely to get your money, or art-work, if you claim it at the earliest possible stage. The worst scenario is that a gallery closes down and you don't hear about it until all assets have been disposed of. If a gallery becomes uncommunicative and stops telling you when works sell, this should ring alarm bells and further work should not be supplied.

Artists should know that 'bankruptcy' means that sole traders and partners can no longer pay their bills, so are wound up either forcibly or voluntarily. This is called 'liquidation' for limited companies. A 'receiver' is appointed by someone who has lent money to a business, and is only responsible to that one person, whereas a liquidator is resonsible to all creditors.

Gallery owners as agents

Gallery owners sometimes act as agents for their artists in obtaining, negotiating and handling publishing contracts, corporate commissions and wholesale customers. A gallery owner may, for example, arrange to give an artist one exhibition per year, and negotiate on the artist's behalf with book and print publishers (see Chapter 11: 'Agents' for more information).

Gallery owners sometimes ask agents to negotiate deals for their artists with print and card publishers. They see this as part of their role in promoting their artists, but prefer to hand it over to someone with expertise in this field. Most gallery owners would expect agents to pay them introductory fees for this opportunity.

Once an artist and a gallery owner have worked together for a while, the gallery owner may decide that the artist's reputation would benefit if their work were exhibited elsewhere, and will set about arranging the exhibition. In this instance, the gallery owner turns agent, taking over the task of negotiating and organising the exhibition of the artist's work at another gallery (be it public or privately owned). This is most likely to happen at the top end of the market, where an artist's work is fetching high sums and the gallery owner is prepared to invest a lot of time in developing an artist's reputation.

Chapter 8

Case studies: agreements between artists and galleries

Agreements and contracts are never standard, but vary enormously. An agreement that suits one artist or gallery owner will be unsuitable for others. For that reason, this chapter features a number of case studies. (These case studies are based on real agreements, but for obvious reasons the names have been changed.)

Agreement between

The Old Fire Station Gallery and Joan Robertson (artist)

For a solo exhibition

1. The exhibition will run from 5 p.m. on Wednesday 8th November 2005 until 5 p.m. Wednesday 22nd November 2005. The main gallery will be devoted exclusively to the above-named artist's works; the upstairs and rear galleries are not included in the exhibition and will contain works by other artists. The exhibition is to be entitled *An African Journey*.

2. The artist agrees to provide 60 watercolour paintings for the exhibition, 50 of which will be hung at any one time. Each painting must be a minimum of 14in x 16in (unframed), must be executed in detail, and must depict scenes of African life and landscape. The Director of the gallery must be contacted periodically during their creation to be kept informed as to how work is progressing. Completed and framed works must be delivered to the gallery one week before the start of the exhibition.

3. At least 30 pictures must be finished and available to the gallery photographer 6 weeks before the start of the exhibition.

4. Artwork must be framed to a professional standard (to be determined by the gallery); otherwise the gallery may reject the artist's framing. The gallery offers its artists a discounted rate for framing if that is preferred. If the gallery's framing service is used, the artist must pay for the cost of framing before the start of the exhibition.

5. The artist will pay: the cost of framing; 50% of the cost of the catalogue, including photography, design and printing; 33% of advertising costs; delivery to the gallery of all works and collection of any works unsold at the end of the exhibition. Expenditure will be discussed in advance with the artist. The gallery undertakes that the artist's share of catalogue and advertising costs will not exceed £2,500 without prior discussion and agreement.

6. The gallery will pay: the balance of costs with respect to the catalogue and advertising; postage; the cost of putting on the private views; insurance; all other costs incurred in promoting the exhibition.

7. The artist is expected to attend private views on November 8th and 9th, between 12 noon and 2.30 p.m., and 6 p.m. and 9 p.m., on both those dates.

8. The artist will supply the gallery with a list of clients' names and addresses at least a month before the start of the exhibition. The gallery will treat these as confidential and will only use them in the promotion of this one exhibition.

9. The artist will supply biographical details at least six weeks before the start of the exhibition. The gallery will be pleased to borrow good-quality reproductions of work that is to be included in the exhibition.

10. The gallery is responsible for insuring the works from the time they arrive in the gallery until the artist collects them at the end of the exhibition, or until a sale is completed and the works concerned are transferred to their new owners. Works are insured while with the gallery, in transit or on loan to a third party. If they are lost, stolen, destroyed or damaged, the gallery will pay the artist the agreed retail price less the gallery's commission.

11. The artist retains copyright of all paintings in the exhibition. The gallery reserves the right to reproduce any works up to 8in x 10in on promotional material (e.g., posters) for this exhibition only; promotional material will not be offered for sale.

12. The gallery will retain 35% + VAT commission; the artist will receive the remaining sum or a minimum return of £500 per framed picture sold – whichever represents the greater amount.

13. The artist will be paid 14 days after the exhibition closes.

14. Discounts of 10% will be split between the artist and the gallery. The artist will be consulted before larger discounts are given.

15. In the unlikely event of sales totalling less than £1,500, the artist will be asked to pay 20% of the costs of invitations, postage, private view and posters. This would be in addition to the expenditure detailed in point 5.

16. Commissions secured by the gallery for the artist during the exhibition will be subject to the same terms as above. The artist will be consulted as to the price and timescale for such commissions. The artist must produce preliminary sketches, as well as further sketches as the job progresses, for the gallery to show to the client.

17. Unsold works must be collected by the artist, at her expense, within a week of the close of the exhibition.

I agree to the terms stated above:

Signed _____ the artist

Signed _____ Director, The Old Fire Station Gallery
Date _____

THE RED DOOR GALLERY
26 HIGH STREET, HALIFAX, W. YORKS. HX5 2DP

21st June 2005

Ms Alice Dupont
Flat 3
26 Raymond Avenue
Leeds LS2 3DB

Dear Alice

I was very pleased to meet you last week and liked your pictures very much. Thank you for bringing them up for me to see.

We would be delighted to have an exhibition of your work in the main gallery here in Halifax and propose that it should open on Tuesday 17th October and end on Saturday 11th November.

We suggest the following:

a. We will take 40% commission + VAT
b. You will be responsible for the cost of framing
c. We will prepare and pay for a three-page brochure in colour and will mail this to whoever we feel should see it
d. We will pay for a simple opening party on Monday 16th October, which you will attend.

We are very pleased to be showing your work and look forward to making further plans nearer the time.

Yours sincerely

David Higgs

David Higgs
Director

Agreement between

The Petersham Gallery, High Street, Cheltenham
and Charlotte Adair

12th July 2005

This letter is to set out the arrangements we have agreed with you concerning our right to exhibit and sell your pictures and our readiness to advance to you money against those future sales.

The arrangements are as follows:

1. As long as these arrangements last, we will be your sole agents for the exhibition and sale of your pictures, and you agree not to sell, or otherwise dispose of, any pictures directly on your own behalf or through any other gallery or agent without our permission. In this letter 'pictures' means paintings, drawings and watercolours.

2. We shall exhibit your work at our gallery and, provided that you are able to supply us with sufficient new pictures for the purpose, we would aim to have special exhibitions of your work two, or perhaps three, times during the next five years.

3. The cost of mounting those special exhibitions will be divided in the following way. We will pay 50% of private-view costs, 50% of PR costs and 50% of catalogue costs. You will pay the other 50%, bearing in mind that the gallery will pay all other exhibition expenses such as postage, photography, transportation, insurance, and other printing and promotional costs. We will pay suppliers and then deduct your share of costs from sales proceeds. In the unlikely event of sales proceeds being insufficient to cover your costs, we will still expect you to pay your share. We anticipate that your share of costs will be around £3,700 and will seek your consent if costs rise above this. The gallery will consult you on those aspects of the show that you are helping to finance, and will make every effort to act upon your suggestions. However, the final word on matters of design, etc., is the gallery's.

4. You retain overall copyright for the works, but we can reproduce them for the purposes of advertising and promotion.

5. In respect of any pictures sold by us we shall be entitled to commission of 40% of the purchase price plus VAT on that commission.

6. Initially, we will bear the cost of framing and mounting your pictures, if you so request, and framing will be carried out by our appointed framers. The cost of framing each picture will not exceed £150 + VAT without your prior agreement. These costs will subsequently be deducted from sales proceeds. In the unlikely event of sales proceeds being insufficient to cover the cost of framing, you will pay the balance.

7. We will make available to you by way of an advance a maximum figure of £10,000, which you may draw on at a rate not exceeding £2,000 per month, the first of such payments to be made available on the 1st of next month.

8. Any sums so drawn by you will be an interest-free loan to be repaid out of sums due to you upon the sale of any of your pictures.

9. If any part of these loans or your share of expenses remains outstanding when these arrangements come to an end, then:

a) We shall be entitled to retain any pictures in our possession and to discharge the amount outstanding from the proceeds of sale of such pictures due to you after deduction of our commission; and

b) If, after such sale(s) within three months of termination, any part of the loan or costs still remains outstanding, we reserve the right to acquire from you at their then-estimated market value (less monies still outstanding) such of your completed pictures as we may select in full and final settlement of any claim which we have against you.

10. These arrangements will continue to be binding upon your personal representatives, heirs and assigns in the event of your death.

11. These arrangements may be brought to an end by either of us giving to the other three months' written notice, with the two provisos that:

a) Once a special exhibition of your work has been publicly announced, these arrangements shall not be brought to an end until the exhibition has ended, and

b) If we have incurred expenses in preparation for a special exhibition that has not yet been publicly announced and you give us notice to end the arrangements, you will reimburse to us the expenses in question.

I agree and confirm the arrangements between us as set out in the above letter dated the 12th day of July 2005.

Signed _____

Date _____

Chapter 9

Selling direct

In addition to working with privately owned commercial galleries, several other promotional and sales opportunities for artists are examined in this book (publishing and licensing are discussed separately in Chapters 13, 14 and 15). Before embarking on selling direct, however, you need to consider the sales and marketing techniques that you will use. Chapter 10: 'How to make exhibitions work' addresses this important issue in detail, but it is essential to develop some sales and marketing skills in order to make the best of any opportunities.

Many artists sell direct to the public as well as via galleries and publishers; as long as each party is informed as to what is going on there need not be a conflict of interests. Quite the reverse: artists who are proactive in developing their own reputations and client lists can be an asset to galleries and publishers.

Depending upon the agreement you have with your gallery, you may get to keep all the sales proceeds when you sell direct (some galleries/agents take a lower percentage on sales artists generate themselves. See section on 'Studio sales', Chapter 7: 'Terms and conditions between artists and galleries'). While avoiding commission of course sounds appealing, some capital expenditure, as well as a lot of time and effort, is normally involved in selling direct.

Some artists enjoy organising open-studio weekends, taking stands at art fairs, etc., as it keeps them in touch with the demands of the marketplace. This direct involvement with buyers can prove fruitful in the development of their work. But there are many ways in which you can make direct sales, and the most common ones are discussed below.

Studio sales

Many artists achieve a high percentage of their turnover at annual open-studio days or 'artists at home' initiatives. These are often timed to coincide with other cultural and artistic events in the local area that will attract the right type of visitor, such as festivals, art-college degree shows, local-authority art weekends, and so on. Artists often get together with others in their area, or their studio complex, to produce joint marketing material. It is important to invite clients as well as local gallery owners to open-studio shows. It is also a good idea to send press releases to the media and to make contact with the PR agents for any cultural and artistic events in which you are taking part.

Rented gallery space

There is a big difference between on the one hand an artist renting gallery space and on the other a gallery owner exhibiting an artist's work in their gallery. You will have full control if you rent space, as well as more potential income, though you also face far greater costs, risks and workload.

If you rent space you have to handle marketing and administration, and you need to have your own substantial client list. The effort involved in mounting a show should not be underestimated: staffing the exhibition; making decisions about publicity; designing, pricing and distributing posters, flyers and invitations; invoicing and accounting; delivering and hanging/installing artwork, etc. Artists are not usually experienced at making these decisions, whereas gallery owners are.

The main advantage of renting space is that it cuts out the gallery owner's commission. But commission covers far more than just a gallery owner's time and wall space; you are also benefiting from:

• their reputations and loyal clients
• their expertise in running exhibitions and selling art
• a contact for future purchases and follow-up sales.

Remember that the more time you put into administration and marketing, the less time you have in which to work at your art.

All business people have to make decisions about the best use of their limited time, artists included. It may be that the 10% to 30% commission charged for rented space is not a better deal than the 40% to 60% charged by professional galleries and their staff. Also, rental fees need to be paid upfront whether the exhibition is successful or not, whereas a gallery's commission is only payable on sold works.

One of the main disadvantages of renting space is that you will have to draw up your own guest lists. Exhibitions are unlikely to be successful if they rely solely on passing trade, mailshots and advertising. Lists of established clients are essential. Gallery owners put a lot of effort into developing such lists, which are an integral part of their business. Some clients will buy from gallery owners on the basis of their recommendations alone.

The terms and conditions imposed by galleries which rent out space vary considerably. Some stipulate that they must approve proposed exhibitions; some provide staff to oversee exhibitions and help with selling, etc. Rented galleries can be either privately or publicly owned. The rent that different galleries demand varies enormously. For example, galleries in the West End of London can charge several thousand pounds for two weeks' rent, while those in less glamorous locations may charge only a few hundred.

Consumer art fairs

These can range from small local events in church halls to shows that are marketed via the national media and held at household-name venues. There may be just a handful of artists taking part, or there may be hundreds. Consumer art fairs may be cooperative, commercial or publicly funded. Some only allow artists to submit works for exhibition, not 'middlemen' such as galleries and agents. This possibility is discussed further in Chapter 10: 'How to make exhibitions work'.

Trade exhibitions

Large gift and interior-design exhibitions give artists the opportunity to reach galleries, publishers, department stores and other trade buyers. They are generally attended by international and UK buyers

and are a way for artists to establish a wide range of channels of distribution and repeat business. Some exhibitions have sections with affordable stands to rent, specifically aimed at artists. Organisers are keen to attract new talent each year, and so might even be able to put you in touch with public and charitable funds that will help cover exhibiting costs. This possibility is discussed further in Chapter 10: 'How to make exhibitions work'.

The Internet

The Internet provides a way for interested parties all over the world to get in touch with artists, and it can only be a good idea to pursue as much useful exposure as possible. Artists can sell via their own websites and through information held on other related sites.

Many artists start by submitting JPEGs to organisations of which they are members, as well as to various arts registers and virtual exhibitions. You should make sure to take advantage of all offers of inclusion on quality websites, such as virtual catalogues for art fairs and local-authority sites.

Public funding is often available, from basic computer training right through to sophisticated web-design courses. There are even government grants for buying computer equipment and setting up your own website. Each region offers different opportunities for funding, so be sure to investigate these thoroughly in your own area.

Consider carefully whether you can afford to set up and run your own website, the cost of which can vary enormously. Virtually every professional business now has its own site, so it follows that a website could play an important role in reassuring buyers and gallery owners that you are committed to your career.

Many artists find that their site generates a lot of business from both new and existing clients. Before you start, it is important to consider what you want the site to achieve and how much time and money you realistically want to invest in keeping it updated. Some artists see their site as a low-key presence on the web that will enable people to find and get in touch with them, and to which they can direct customers to view a selection of their work. Others want a more proactive site: they are prepared to spend time and money staying at the top of search-engine lists, and may even have invested in 'secure shopping' software

so that they can make sales over the Internet. It is important to have as many reciprocal links to other sites as possible, so that your site works as hard for you as it can.

However, despite the obvious temptations, if you have an agreement with a gallery or publisher it is important that any website you set up is not operating in competition with them. The website should simply publicise your gallery exhibitions and direct browsers to your publisher's site for a range of prints. Any gallery or publisher who is serious about your work will not thank you for undermining their efforts to sell it.

Field sales

Most retail buyers will not see a sales person (which in this context is how an artist would be seen) without an appointment, and many will not give an appointment without a referral or recommendation. However, many artists do succeed in selling their work by establishing relationships with galleries and then visiting them regularly with new stock. This type of trading relationship is most likely to develop between self-publishing artists selling reproduction prints and their galleries. Sometimes initial contact is made at a trade show, or the gallery gets in touch with the artist in response to an advertisement or mailshot.

Publicly-funded opportunities

Millions of pounds of public money is given to artists in Britain every year. It is important to keep in touch with local councils and their galleries, and to be aware of their arts policies.

Opportunities for exhibiting include publicly-owned exhibition spaces and galleries, as well as galleries that are partially funded by public money, among which are:

- national galleries
- regional art galleries
- spaces funded by local councils
- arts centres that receive both public money and private sponsorship
- art colleges and adult-education centres
- community centres, town halls and libraries.

The selection policies of these galleries vary enormously, both in terms of acquisition and exhibiting. Some public galleries have a specific policy not to consider direct approaches from artists; some specialise in hosting travelling Arts Council exhibitions; while others have a policy of encouraging local artistic talent. Some mount commercial exhibitions, with artwork for sale, while others put on solely educational displays. Rates and terms of payment also vary considerably, and some public spaces do not charge a fee.

Pay a visit to your local library, read the art press and visit arts websites, subscribing to email newsletters where possible. Also, find out who to contact at your local authority for information on local arts funding.

Publicly funded patronage might include:

• awards, scholarship programmes and competitions
• grants for specific projects
• subsidised studio space or conversion grants
• exhibitions and exhibition spaces
• allowing local artists to hang work for sale in public buildings
• commissioning or buying works for public buildings and schools
• a policy to develop a collection of works by local artists
• employing artists to work with schools or prisons
• computer training and other subsidies (see 'The Internet' above).

Exhibiting societies

Exhibiting societies range from small local art circles to well-known institutions such as the Royal Academy of Arts. Some organisations limit their exhibitions to members' work, while others allow non-members to put up work for selection. Membership can be restricted to artists living and working in particular areas, e.g., the Royal Scottish Academy; or it can be based upon artistic specialisation, e.g., The Society of Aviation Artists; or else it is based on a specific artistic medium, e.g., The Society of Wood Engravers.

Election procedures vary. Some organisations have different levels of membership, such as associate and full members; some are restricted to a specific number of members, and so on. Fees and commission charges usually reflect the success and prestige of the organisation's exhibitions. Membership benefits can include exhibition opportunities; informative

publications; discounts on materials; legal advice; pages on the organisation's website and a link to member-artists' own sites; recommendations and artistic commissions.

Membership of arts organisations keeps artists in touch with each other and broadens their sphere of contacts. Gallery owners tend to visit these exhibitions and often select new artists from them. Many artists are discovered by gallery owners at the Royal Academy's Summer Exhibition, for instance, or at important regional shows such as the Royal Scottish Academy's annual exhibition.

Competitions

You should enter competitions wherever possible. Winning a competition, or being a finalist, is often an important step forward in an artist's career, getting them noticed by gallery owners. Competitions are usually advertised in art magazines and tend to be organised by exhibiting societies, with prizes sponsored by suppliers of artists' materials, large companies or commercial gallery owners.

Chapter 10

How to make exhibitions work

The great thing about taking part in art fairs and trade shows is that the buyers come to you. Exhibitors can see thousands of art buyers in just a few days. However, taking stands can be a costly business, so planning and preparation are required to make the most of this expenditure. The effort can be very worthwhile. The Association of Exhibition Organisers (AEO) reports that exhibitors expect 18% of their annual new business to be gained at exhibitions.

The first step is to double-check that the exhibition you have in mind is the right place for your work. It is not a good idea to book space at a show that you have never been to in person; if the show is new it is best to wait and see how the first year goes, as many shows fold after a single year. So visit the show and look at the other exhibitors; check that their price and product ranges would complement your own. For example, if most of the exhibitors are selling prints and cards, and you produce only original work, then it would probably be best to give the show a miss, as the right buyers are unlikely to attend. Ask other exhibitors and people in the trade what they think of the show, look at the organiser's track record, find out how long it has been running and whether it is increasing or decreasing in size.

The visitor profile

It is important that you take the time to find out about the type of buyer who will be visiting the show, and focus your stand accordingly. This will affect every decision you make about the exhibition, from how you present your work, to the design and content of your sales literature, and the choice of work that is displayed. For example, sales literature aimed at independent gallery owners at trade shows will convey a different message to that aimed at members of the public buying original art at an art fair.

Direct costs

Stand space is usually the largest cost, although freight can be a major expense when exhibiting overseas. On top of the cost of stand space, you may need to invest in display easels, a folding table, a floor-standing cradle with sleeves to display works on paper, leaflet dispensers, card spinners, lighting equipment, etc. This equipment can usually be rented from the organisers, but the cost is often high, so if you plan to take part in several exhibitions the cost of buying it is quickly recouped.

Check what is included in the standard exhibitor package, as this will differ from show to show. For example, some shows include lighting in the basic package and some do not. Some provide Velcro display panels, while others provide 'walls' which can be painted and can have nails banged into them.

Keep graphics simple, if any are needed. Maybe just include your name, logo and specialities. There is no point in being too wordy as visitors are unlikely to read much during an exhibition. A few eye-catching words and images are what is needed.

Exhibition hardware, including signage, needs to be as lightweight as possible. Also consider the size to which equipment folds, as this may affect your transportation costs. There are ingenious display stands and tables available that fold into tiny suitcases on wheels.

Other financial considerations are transport and hotel bills. If your work can be fitted in a car, so much the better; otherwise the cost of hiring a van needs to be considered.

Displaying the work

Hang your best work at eye level and do not overcrowd the stand. A haphazard market-stall look will not win the confidence of most buyers. Many artists use browsers and cradles to display less expensive work. Glazed work is at risk in crowded exhibition environments, so some artists prefer to show their work just mounted, or with a frame and no glazing. Make sure you know how your work will be hung at the show.

A general rule seems to be that the more expensive the work, the less likely it is that the price will be openly displayed next to the painting. Inexpensive prints are nearly always accompanied by a clear price list or label, whereas oil paintings that are selling for several thousand pounds tend not to be visibly priced.

Taking money

Artists will lose out if they cannot accept payment by debit and credit card, particularly at shows where they are selling direct to the public (as opposed to trade shows). Credit cards also make taking money from overseas buyers straightforward; foreign cheques and money transfers can be complicated and can thus deter the impulse buyer, whereas handing over their plastic takes seconds.

Some shows offer a credit-card service to exhibitors, which means that exhibitors don't need their own merchant-services account. Otherwise, the first step is to approach the bank about setting up such an account. You will have to pay the bank a percentage of your takings, but there is no way round this in today's marketplace, where people expect to be able to pay with cards. The alternative is to lose business.

Commission rates with banks are negotiable. You may not be able to negotiate a very good deal initially, but you should also beware of tying yourself into a high rate for too long. Try to renegotiate the deal as soon as you can. Sometimes all it takes is a quick call to the bank saying that someone else is offering a better rate and they will come down immediately. The Fine Art Trade Guild offers competitive rates to members through its own merchant-services scheme. You will need access to a telephone line to authorise credit-card payments. If mobile-phone reception is not good at the venue, you will need to think of a way of overcoming this problem, so discuss this with your bank.

Gallery customers are likely to want an artist's original work on a sale-or-return basis, as discussed in Chapter 6: 'Pricing original work'. You need to do some research before handing over your work to a gallery. You should follow up references and ask other artists about the gallery. Consignment notes will need to be completed and terms agreed (see Chapter 7: 'Terms and conditions between artists and galleries'). It would not be too much to expect a gallery to buy a few pieces out-right at this stage, to show some commitment to you. Above all, don't hand over any work until you are completely happy with the details of any arrangements you have made.

Remember that galleries tend to buy prints and cards outright, rather than on a sale-or-return basis. They might ask for a pro-forma invoice, which in this case means that as the artist you send them an invoice, and when this has been paid you dispatch them the goods. Once a good trading relationship has been established, it would be normal practice for you to set up a trade account with the gallery, to be settled once a month. That way, goods can be quickly dispatched whenever the gallery places an order.

Sales literature

Prospective buyers need something to take away when they visit an artist's stand, so that they can get in touch in future or browse the artist's website in their own time. Sales literature ranges from a simple business card to an illustrated catalogue. The main thing is that no one goes away empty-handed. Artists can produce their own leaflets on their home computer, or, for large quantities, it may be just as cost-effective to get them professionally printed (printing consumables are expensive). Sales literature should of course mirror the style and colours used on the artist's exhibition signage, website and portfolio.

Many artists opt for postcards with a colour illustration on one side and text on the other. Since this format is so popular, there are printers that specialise in offering this service to artists at competitive rates. Handing out something postcard-size or smaller has the double advantage of keeping your costs down and of offering people something small to hold on to, in contrast to bulky catalogues which often end up in the bin. Leaflets or brochures with more than one illustration, however, do give an artist more exposure and therefore increase the chances of making a sale.

CDs featuring a selection of your work can make good handouts. These need to be clearly labelled with contact details. As many office printers can now print directly onto CDs, this should not be a difficult procedure. It is best if any CDs are accompanied by a visual reminder of your work, such as a postcard or insert in the CD cover, to entice people to go to the effort of putting the disc into their computer. It is becoming more and more cost-effective to buy blank CDs and cases; burning images onto the disks should be quick, as only low-resolution files are required. There are also bureaux offering competitive rates for burning large quantities of CDs.

Advertising and publicity

You should take advantage of all the pre-show publicity opportunities offered by the organisers. This is all too often forgotten in the rush of getting everything else ready, but is in fact just as important as dressing the stand properly. You'll have a head start over the competition if buyers have already seen your new work and are considering it even before entering the exhibition hall.

Check whether the press office welcomes images from exhibitors to send out to the press, and be sure to provide these at every opportunity. Take the time to write the best possible entry for the show catalogue. Find out which trade or art magazines and websites are running show previews and submit information to these publications.

Before booking any advertising, carefully consider whether the cost is justified in relation to the exposure that will be bought, and check that the publication is going to the people you most want to see your work. Find out if an advertisement also entitles exhibitors to a write-up in a show preview.

Pre-show contact

Invite your best customers to come to your stand; many organisers give exhibitors a few free VIP tickets that you can send out to your most valued customers. They will of course be pleased not to have to pay the entry fee. Notify customers about any new work you plan to unveil at the show, or any special show-only discounts and offers. Invitations give visitors a compelling reason to stop at your stand.

Special offers and other attractions

Make sure any special offers on your stand don't look tired and tacky: hand-drawn signs saying '10% off at the show' will never impress anybody. Nevertheless, they do work, especially if your pre-show publicity campaign has promoted such offers. Special offers entice buyers to part with their money there and then, and help convince them that they are getting a good deal. Offers might typically consist of 'three prints for the price of two', or 'ten free greetings cards with every sale', or '20% off all frames'.

Many artists find that practical demonstrations of their painting techniques pull in the crowds and make a good sales aid. To pull this off you will of course need both enough space to work in and someone else to help with selling. You will also need to check with the organisers that this type of demonstration is allowed at the show.

Albums of press cuttings, past catalogues, etc. should be brought to the show. These can be used to reassure potential customers that artists are what they say they are, and they can also be used to engage customers in conversation.

Face-to-face selling

Many artists understandably hate the idea of selling their own work. However, they can be the most successful art salespeople of all. It is a myth that someone cannot be a creative artist and a salesperson; these roles are not mutually exclusive.

Most people, not just artists, squirm at the idea of foot-in-the-door salespeople and thick-skinned, pushy telesales people who invariably call at the worst time, and won't go away when asked. It is certainly not a good idea to adopt this type of sales technique; successful selling is largely about enthusiasm, sincerity and being helpful.

Buyers like the idea of talking to the creator of the work they are about to buy. This is perhaps where romantic notions about the lives of creative artists work to an artist's advantage. Many people rather envy artists their apparently unconventional 'arty' lifestyles, and for some people buying a picture means buying into this ideal. No one can better embody this fantasy than artists themselves.

Here are a few tips on successful face-to-face selling for artists:

Contact with the artist

The artist can make a buyer feel special in a way that no other sales-person can. People enjoy hearing about the ideas behind a particular work. They are flattered to be 'let into secrets' about the creative process. These titbits of information about a work can be used to 'explain' it to their friends when they have the picture hanging at home. Artists sometimes clinch a sale by offering to dedicate a work to a particular person, or commemorate a particular event (such as a wedding anniversary), by writing a congratulatory note on the window-mount or stretcher bars. Adding a quick hand-drawn cartouche to the margin of a reproduction print can make a buyer feel they are 'getting something for nothing', which always helps make a sale. It is far better to clinch a sale by offering 'the personal touch' than to resort to offering a discount.

Enthusiasm

Enthusiasm is infectious . . . as is doubt, boredom and lack of interest. It is essential to convey enthusiasm for your work and for the job of meeting people and selling to them. Art is a luxury, so people need to enjoy buying it. They need to feel that owning a piece of work will somehow uplift them and improve their lives, otherwise they might as well go and spend their money on something else. Try to give the impression that nothing is too much: take the work off the wall and hold it in another type of light, hold a range of frame samples against it, produce further examples from under a table. All of this will both put customers at ease and make it that little bit harder for them to depart without buying.

Existing customers

It is always said to be far easier to sell more to existing customers than it is to make new ones. You should therefore make even more effort when you spot an existing customer; maybe offer them a drink or a seat, offer them something special (such as a few free greetings cards) or just set aside more time for them. Your aim should be to make your existing customers feel good.

Body language

It is important to make eye contact with everyone who approaches the stand and to greet them with a smile. If you are too busy to attend to them straight away, then take the time to invite them to browse. Try to engage visitors in conversation; don't just ask questions to which the answer is 'yes' or 'no', but try something like 'Are you more interested in landscapes or marine subjects?' or whatever is appropriate to your work. Don't let yourself get too tired to deal with customers properly; when that starts to happen you need to call in back-up and take a break.

Closing a sale

If someone is hesitating, don't start by offering a discount to encourage them to buy; don't assume that price is the barrier. Talk to the customer and listen carefully; find out what the stumbling block is and try to overcome it. For example, it might be the frame, the colours or the size. Offer practical suggestions and loads of enthusiasm, as well as reassurance that the customer is making a good decision, saying things like 'I have had such a good response to this new design', or 'I'm going to have to put the price up straight after the show or I won't be able to keep up with demand'. Point out that the show is going really well and that the item is unlikely still to be on sale at a later stage. Sometimes a timely, free add-on such as free delivery will help close a sale.

Following up

It is essential to follow up all sales leads after the show. According to the US Center for Exhibition Research it takes an average of 3.6 personal sales calls to close a sale, but this decreases to 1.4 calls after an exhibition.

Exhibitors should routinely collect business cards and contact details during shows. At trade shows most people carry business cards, and you should always encourage them to leave one with you, perhaps with the enticement of a prize draw. Most buyers are also happy to sign a visitors' book.

Ideally, you should jot down a few notes on the back of every business card relating to that particular visitor's enthusiasm for the work on

show. However, there is not always time to do this, so some exhibitors resort to a grading system, writing 'H' on a card that is a hot prospect, 'L' for a long shot, and so on.

Prospective buyers should then be added to your database. You should contact visitors soon after the show has finished, maybe sending more-detailed sales literature, and making clear how successful the show was for you. It should be possible to see how many 'potentials' from a particular show turn into real buyers, which will help you when deciding whether to take a stand at the same show again next year. Exhibiting professionals consider that a good show should generate ten times more revenue than it cost to take part. However, don't expect this level of business immediately; plan for three years of good exhibiting before you achieve this kind of turnover.

Chapter 11

Agents

Sales agents, artists' agents, licensing agents . . . do they make money for artists and suppliers, or are they an unnecessary overhead? The short answer is that good agents are to be treasured and bad ones can greatly damage an artist's reputation. Once again, knowledge is power, and you can protect yourself by thoroughly researching both the overall marketplace for agents and the specific agent with whom you are thinking of working.

Artists tend to see agents as people who will save them trouble and, almost too good to be true, make them more money. Galleries and publishers often see agents as an unnecessary complication to their relationship with an artist. In reality, both views are a little simplistic.

There are fewer agents now than there were 20 years ago: it is not an easy way to make a living. Being an intermediary between artist and gallery or publisher is not exactly stress-free, and as competition increases so the margins decrease. Nowadays, there is not enough profit in the average sale or licensing deal, and sales are not frequent enough, to allow for percentages for artist, agent and a third party. It is now more common to see a gallery owner also acting as agent for their own artist, or, very often, the agent is a member of the artist's own family prepared to work on less favourable terms.

A good agent can save an artist time, will have contacts not accessible to most artists, and should have the skills to negotiate better financial deals. Busy agents also tend to represent a range of artists, so they may have a better chance of being seen by potential customers than the artists themselves. Some artists hate selling their own work, which may be very personal in nature, so they prefer to take on an agent with practised sales skills who will be able to negotiate on a more objective basis.

Some artists and manufacturers do not use agents at all, preferring to reach customers through trade shows, the Internet and advertising. Others would feel vulnerable if their relations with customers were all conducted through a third party and they knew nothing about the marketplace; they fear that their income would collapse if the agent dropped them, or feel that they need direct feedback from the market-place to help them develop their work. An artist who becomes too removed from the art-buying public may worry about being able to respond quickly enough to changes in taste and demand.

Types of agent

There are four main categories of agent:

Artists' agents

An artist's agent handles the business side of an artist's life. Many artists' agents are primarily gallery owners and publishers who handle some aspects of their artists' work, but do not take over the entire running of their business lives. A large number of artists are represented by their domestic partners or members of their families, who have a vested interest in their success and are thus prepared to take a long-term view of the project rather than expect immediate remuneration. They are also more likely to be loyal.

It is important that the extent of the agent's role is clear from the outset. For example, this might include organising exhibitions, handling media relations, developing a publishing programme, licensing work, liaising with galleries, debt collection, and day-to-day administration. The scale of remuneration should also be clearly understood, as well as when payments are to be made and when terms are to be reviewed. This will be affected by the reputations of both parties, i.e., who needs who the most, and the price of the artwork being sold. It will also depend on who is funding ventures such as the

printing of catalogues, renting exhibition stands, photography costs, etc.

The financial side of this type of relationship is unlikely to be standard, as each agent is likely to have a slightly different role. For example, some agents pay their artists a retainer or an advance, while some artists employ their agents and pay them a monthly wage. An agent selling secondary licenses to greetings-card publishers will not expect the same commission structure as an agent handling media relations.

Sales agents

This type of agent is probably a self-employed sole trader 'on the road' selling a range of reproductions, ready-framed pictures, greetings cards and gifts on behalf of perhaps four businesses and/or artists. Sales agents handle sales but do not contribute towards other marketing or production costs. They pay for their own car, petrol, hotel bills and insurance.

Many sales agents expect financial back-up from their artists in the form of a promotional programme (advertisements, mailshots, trade-fair stands, etc.), and offering this kind of back-up is a good way for an artist to attract one of the better agents.

Distributors

Distributors are companies rather than individuals, and they tend to cover the whole country. They are often successful sales agents who have developed into larger concerns employing sales agents of their own. Distributors normally work to develop a corporate image. They have their own marketing programmes involving advertising, stands at exhibitions, trade showrooms, catalogues, etc.

Licensing agents

These agents negotiate licensing deals with print and card publishers, porcelain manufacturers and giftware companies. Good licensing agents should be able to negotiate better terms and have a wider range of contacts than artists representing themselves, even taking their commissions into account. Some publishing companies, however, will only deal with artists direct. Many print publishers and gallery owners also act as licensing agents for their artists.

Research is essential

Finding good agents is not easy. It pays to be cautious about agents working part time and those who cannot demonstrate a good track record. It is easy to set up as an agent; the costs are low and no qualifications are needed, so all sorts of inexperienced people may call themselves agents. However, the skilled and committed can earn a very good living; though they do have to work long hours. Most agree that being an agent is not an easy way to earn a living, which perhaps explains why agents tend to come and go with greater than average frequency.

You can visit a gallery before committing to them, and will most likely have had meetings in a publisher's office before signing anything. It is much harder to assess an agent's level of professionalism, as they tend to be sole traders working from modest premises.

It is essential to try and find out all you can about a potential agent's other clients and customers. This will help you to assess the quality of the agent. It is in the agent's favour if he or she has held onto well-respected artists over a long period of time. All too often you hear of agents who have disappeared with products or have illegally reproduced work; the more research you do before taking on an agent, the less likely this is to happen. Agents often require a car boot full of stock before any sales can be made, so you need to make sure that they will not disappear without trace the moment you have handed over such a large amount of work.

Consider also an agent's customer base. There is no point in paying an agent to do what you could do better yourself: while an agent may claim to have the key to many secret markets, in fact these markets may well be businesses that you could contact directly yourself, or with whom you already have a working relationship.

Ask potential agents how they sell work, e.g., by advertising, taking stands at trade shows, travelling, etc. Find out how long they have been in business, which areas of the country they cover and so on. Consider whether they are registered for VAT (this indicates a high level of turnover and therefore commitment).

The work of other artists that an agent represents should complement your own style but not be so similar that there would be any conflict.

The price range of this other work should be broadly similar to your own. Look at their present stable of artists and consider whether they are likely to be visiting the type of customer who would buy your work.

Find out how many other artists and businesses the agent represents, in order to assess whether they realistically have time to devote to promoting your work. An agent carrying more than about six lines might not be devoting sufficient time to each, and customers may get bored looking at too much stock. Some artists will not work with an agent representing more than two or three other suppliers, while others are happy to be one of six or seven.

Good agents are usually likeable and have good interpersonal skills, which partly explains why gallery owners and other art professionals are happy to see them on a regular basis. They need to be pleasant to chat to over a cup of coffee and to have their finger on the pulse of what's selling in the marketplace. Customers often see agents as an invaluable way of staying in touch. Agents are ideally placed to give their customers good advice and information, as they are visiting a range of businesses on a regular basis and representing a range of suppliers and artists.

Good agents have a complementary range of products, which is regularly updated. Good agents also have excellent product knowledge and are honest about what is selling well and what is not.

Look out for conflicting interests when selecting an agent. For example, some print publishers also act as agents for self-publishing artists and overseas publishers; these relationships are often short-lived because the publisher prioritises selling their own work, in which they have capital investment, and see selling other work as a secondary activity. So be sure to assess an agent's commitment to your work; look at their business activity as a whole and assess how significant a role your work is likely to play.

How to find agents

The short answer is 'networking and contacts'. Talk to other artists and contacts you have in the art world; the vast majority of artists find agents through word-of-mouth recommendation. Artists and agents recommend each other; people within the art trade know who is good and who has been around a long time. However, it also helps to read

the right publications, look at the right websites, visit the right shows, and contact any organisations that might be able to help (see Appendix: 'Useful contact details').

You should also make it easy for agents to find you. It is important to take part in degree shows, interior-design shows, gift shows, arts festivals, etc. Scan the art press for suitable exhibitions; quite a few interior-design shows, for instance, have sections for original art. There are a number of business trusts offering subsidised exhibition space for groups of artists. Artists' agents visit these shows and will approach any artist whose work interests them. You often see signs stating 'agents wanted' on artists' exhibition stands; this breathes a slight air of desperation and looks rather shoddy, and will probably not attract the best agents.

Agents often sell their artists' work at art, gift and interior-design exhibitions. Be sure to research these events and visit the appropriate ones. Do not approach agents at exhibitions; they are busy selling and will not have time to talk. Make a note of their details and contact them afterwards.

Sometimes picture framers have sidelines as agents. They meet artists through framing their work and they also know, and probably work for, a number of local galleries. A typical scenario would see a framer asking an artist how much they want for their pictures, adding on between 15% and 30% and then offering the work to the galleries.

Trade magazines tend to have classified and online classified sections where artists can advertise for agents, and agents for artists. Look in interior-design magazines for advertisements from agents trying to sell art; look also in exhibition catalogues and their virtual counterparts for lists of exhibitors at art and trade shows.

Commission rates

The cheaper the merchandise, the higher the agent's commission will be, in order to offer the agent some incentive. For example, an agent selling ready-framed prints for a few pounds a piece may charge 25%, whereas another selling an established artist's work for several hundred pounds a piece may only charge 10%. Commissions tend to vary according to an agent's expenditure and how much they manage to sell.

Commissions are also likely to vary according to whether agents are selling trade (to shops and galleries) or retail (to the public). Commissions on trade sales are likely to be less (approximately 15%) because repeat business is likely, because sales are usually of a greater volume and because the time invested in each individual sale is likely to be less than when selling to members of the public. If agents are selling retail, commission rates might be around 30%.

While the percentage commission paid is of course important, both parties should also consider the likely volume of sales and the price that the agent can get for particular works. For example, it is better to have 10% of £200 than 40% of £20.

Sales agents on the road typically retain between 10 and 25% of sales proceeds. Professional sales agents will typically try to negotiate 20% with their suppliers; they would be happy with 15%, but will only accept 10% on a safe bet. The margins are not generally there to allow for more than a 25% agent's commission.

Some licensing agents advertise themselves as charging fixed fees, while others state that fees are negotiable. If, for example, an agent takes on the management of an existing publisher for a particular artist, the agent may charge a lower percentage than if they had put the two parties in touch in the first place.

Licensing agents typically charge their artists a commission in the region of 30%. However, print publishers who are selling secondary licences for their artists often keep 50% to 70%, though the artist is also benefiting from a print royalty. This percentage may sound steep, but given that greetings-card publishers often pay a flat fee of just £150 per image, it is not worth the agent's while to try and broker the deal for less. If the agent is brokering a deal worth thousands of pounds, their commission may be between 10% and 30%: the extra volume of business compensates for the lower commission rate.

It is standard to pay agents 15% in the card industry, going up to 20% in some cases. Commission rates tend to be lower than these in the gift industry, as margins tend to be lower than for paper products such as prints and cards. Agents acting in the fields of advertising, design and children's book publishing will typically charge their artists between 25% and 33%.

Gallery owners tend to retain around 50% of sales proceeds when selling original work (see Chapter 6: 'Pricing original work'). This is a higher percentage than taken by agents on the road, because galleries often underwrite significant fixed and promotional costs. Galleries also tend to sell retail, thus entitling them to higher commission rates.

The parameters of the role of artist's agent vary greatly according to each individual relationship, so it is hard to give precise figures. Sometimes different commission rates may be paid for each type of deal the agent secures.

An artist's agent may retain a figure amounting to anywhere between 5%-50%, depending on their level of expertise and the relative financial commitments of both parties. Agents who travel the country buying artists' originals might hope to double their money, e.g. buy a painting from an artist for £200 and sell it to a gallery for £400. In this case, an agent has invested their own money in stock, accepting the accompanying risks, and thus they will expect a substantial return. An agent selling work on an artist's behalf will typically earn between 10%-20% commission.

Appointing an agent: key points

The following points need to be clearly understood, and put in writing, if an arrangement between artist and agent is to run smoothly.

The extent of the agent's role

Some artists have an agent for prints, but still market their originals themselves. In other cases artists are allowed to continue to sell direct to existing clients. You need to make it clear to the agent whether you expect them to act as sole agent, whether they cover only a given area, and whether or not specific customers are excluded.

Invoicing and collecting payment

With sales agents this works in two key ways. Either the agent invoices the gallery for all products from all suppliers, then passes on payment, or the agent provides suppliers with sales information and the suppliers issue invoices and chase payment. Suppliers tend to send out goods before being paid, and retailers can be slow to reciprocate, paying their key suppliers before the independent artists with whom they only deal occasionally. Thus debt chasing can become an

important issue, on which supplier and agent must work together.

It can be hard for suppliers to chase debts from retailers they do not know personally, but only via their agent. A particularly bad scenario is when the supplier is unsure whether late payment is the fault of the gallery or the agent.

Some artists and suppliers prefer their agents to collect payment; they demur chasing money themselves, not wanting to hear that their art was unpopular with buyers and did not sell. An agent may find debt chasing easier, being more removed from the product and closer to the customer.

The process for collecting money must be clearly specified. Areas to finalise include:

- how often information changes hands
- the process by which this happens
- who invoices
- who chases debts
- how commissions are paid.

There should also be systems in place for handling late payers: agents should not carry on selling to galleries that owe money. It must be agreed at what point a debt is written off (e.g., after six months) and whether the agent is then entitled to claw back their commission. Some agents are paid commission on sales, while others have to wait for their money until the customer has actually paid.

However, bad debts should not be a significant problem with a good agent. A good agent should only be dealing with reliable customers.

VAT

VAT can be a complicated area. Some agents are registered for VAT, some are not. The same goes for artists and suppliers. You should seek to clarify whether commission payments are net or inclusive of VAT; arrangements will differ according to which of the two parties is VAT-registered. If either you or your agent does not understand the rudiments of VAT law, one of you may find that your payments are 17.5% less than you expected.

For example, if the agent is VAT-registered and the artist/supplier is not, then the agent will invoice the artist for commission + VAT, but the artist will not be able to reclaim the VAT. If the commission owing is £500, the artist will therefore lose a further £87.50 (with VAT at 17.5%).

Frequency of payment to agents

Commissions are generally paid on 'sale of product', exclusive of VAT and carriage. Some suppliers pay their agents monthly, while others wait until invoices are settled before paying commission. Others pay a basic monthly percentage, then the balance when they themselves have been paid. Those that pay commissions in advance tend to do so because they see it as important to be supportive of their agents; you may need to make that sort of commitment in order to win an agent's loyalty, though of course the risk is higher.

Suppliers who wait until they have been paid before paying their agents assert that it would be a cash-flow nightmare to do it any other way. Those that pay in advance generally deduct bad debts from future payments. You should make it clear whether the total cost of the item is deducted from commission payments in the event of a bad debt, or just the agent's percentage.

There is also the potential problem of an agent selling product that the artist or supplier cannot fulfil, and whether commission should be paid on such sales. It may not be the agent's fault that an artist has, for example, sold out of a particular greetings card and forgotten to tell the agent.

Copyright

Copyright is unlikely to be an issue between artists and sales agents, but may be an issue with licensing agents and galleries. An agent needs to be clear who holds copyright in an image, and whether they are selling the image itself, the copyright in an image or a licence to print. There can be no harm in reiterating in a contract who it is that holds the copyright, and that the image cannot be reproduced without permission. For more on this important subject see Chapter 12: 'Copyright and reproduction rights'.

Existing clients and other commissions

Some suppliers have existing clients, or 'house accounts', that they have long dealt with directly. You should let your agent know about arrangements you have of this kind. There can also be grey areas, such as when artists receive commissions direct and do not feel that their agent has contributed to acquiring this business. The gallery may disagree; it could be argued that the artist would not have won the commission, nor been able to ask such a high fee, had not the agent spent several years building the artist's reputation. You could arrange it so that the agent receives a lower percentage of commission for work that is sold or commissioned outside of their immediate control.

Marketing support and communication

Agents need to know what back-up to expect. They need to know how often an artist or supplier produces newsletters, catalogues or online updates. They need to be kept up to date on new lines and special offers. Without this input they cannot do their job properly. You should also arrange regular meetings, lines of communication and sales reports.

Discounts

You should agree a system of volume or loyalty discounts with your agent. Agents need to know how large a discount they can give on which products, and to whom.

The legal position

If you are considering working with an agent, you should familiarise yourself with the 1993 Commercial Agents' Regulations. Even freelance agents have employment rights, so should not be taken on lightly, and even a bad agent may be able to seek compensation if sacked. Notice periods, trial periods, etc. must be put in writing. It is strongly recommended that the content of any contract is checked by a solicitor to ensure that it complies with current legislation.

Chapter 12

Copyright and reproduction rights

An understanding of the rudiments of copyright law is extremely important to any professional artist, whether selling original work or reproduction rights.

It is worth reiterating here that copyright can only be exploited if you have access to high-quality digital files or transparencies from which reproductions can be made. Above all, don't part with sold works until these have been photographed.

Copyright

It is important to know that copyright nearly always rests with the artist, regardless of who owns the artwork. There are exceptions to this rule, such as work that has been specifically commissioned or completed during employment, in which case copyright stays with the commissioner or employer. Freelance artists working for a range of companies should keep this in mind.

If you sell a picture through a gallery to a private client, neither the gallery nor the final owner of the work has the right to reproduce it, e.g. as a greetings card. A painting and the copyright in that painting are two entirely separate commercial entities. With some exceptions, such as China, copyright is now fairly standard around the world: it

lasts for the artist's lifetime and for seventy years after their death. So long as works are in copyright anyone wishing to reproduce them has to seek the copyright holder's permission. Artists can, however, sell their copyright. Sales of copyright must be put in writing; otherwise sales are invalid and cannot be legally enforced.

Galleries and publishers are generally entitled to reproduce an artist's work in order to help sell it – through advertisements, catalogues, JPEGs for emailing to clients and uploading onto their website – but they are not entitled to profit from reproductions of a work.

Reproduction rights

Owners of copyright can sell reproduction rights, or a licence to print, for specific projects while still retaining copyright. For example, an artist can sell the right to reproduce a picture on a run of 20,000 calendars or a dinnerware service while retaining overall copyright. This allows them to sell further licences, whereas once copyright is sold the artist has no say in how that image is used. Licensees might, quite reasonably, want to prevent licensors from selling licences to their direct competitors (e.g., other card publishers), so they might want to include restrictive clauses in the contract. They might, for example, want to state that the licensor agrees not to sell a licence to another card publisher, but is free to sell licences into other markets. You need to consider any restrictive clauses carefully; try to assess whether the proposed restriction is likely to deny you any future revenue.

The licensee is the party who has bought the licence, or permission to print, while the licensor is the person who has sold it (generally the artist).

Selling permission to print

You need to be 100% clear what type of permission to print you have sold, and what restrictions on future commercial activity the sale might entail. If you do not understand the terminology used in the contract or agreement, you must not be frightened to ask for an explanation of its implications.

There are three common categories of sale for copyright and reproduction rights:

1. Artists sell copyright outright. They have no control over the ways in which images are subsequently used, and the new owner of the copyright is free to sell licences as they see fit and to retain all the profits. (Sometimes, however, agreement is reached that copyright will be sold but royalties will still be paid to the artist. See below.)

2. Artists sell copyright for a specific limited purpose; neither artist nor publisher can use the image for any other purpose. For example, if the image is published as a limited-edition print it can never be used for anything else, either by the artist or the print publisher.

3. Artists sell reproduction rights, or a licence, for a specific limited purpose; the artist retains copyright and can continue to profit from it. For example, the artist sells the image for use on a set of table mats, but can then go on to sell it for other uses.

It is essential that you are clear whether or not you can sell licences in the future, whether you have signed the right to do this over to someone else or whether neither party can do so (e.g., for most limited editions).

It is an ethical norm (though not law at the time of writing) in the fine-art reproduction industry that images which have been used for limited-edition prints will not be used for any other purpose or reprint. This commitment may be reinforced by a statement at the bottom of the print or on a certificate of authenticity. This needs to be clearly addressed when agreeing a contract with a publisher of limited-edition prints. Consider carefully the detrimental effect to your reputation if work published as a limited edition is seen by the public in other forms. You need to feel confident that your contract covers this possible outcome.

By contrast, it is ethically acceptable for images published as open editions to be published again as often as desired and in any medium (e.g., as greetings cards, on ceramics and stationery). If the artist sells the copyright, then the new copyright owner stands to profit exclusively from such sales. However, there are exceptions: some publishers insist on owning copyright in order to have control over how the image is used, but will include a clause in the contract stating

a percentage that the artist will receive from sales of secondary rights (see the section on secondary rights in Chapter 14: 'Contracts between artists and publishers or licensees'). If the publisher does allow you a percentage of secondary rights, it can be to your advantage to sell the copyright, as the publisher might be better placed than you are to sell licences.

On the negative side, it could be galling to see a publisher profiting from an image over many years when all you received was a small one-off fee for your copyright 10 years earlier. One way to work out the value you should set on your copyright is to look at your artwork and imagine what you might earn from it if you were to retain the copyright; i.e., you must try to estimate a future income. You should also consider the amount of time that went into producing the pictures; i.e., how many 'copyrights' you could produce in a year.

Finally, if your image (or a detail from it) is to be incorporated into an overall design by the licensee, then this new design may be the copyright of the licensee. You need discuss with the licensee how this might affect your own future use of your own copyright.

Chapter 13

Working with publishers and licensing work

As well as selling their originals, artists can profit from reproductions of their work. The fine-art publishing industry, which includes prints and posters, is thriving and competitive. It is also common for artists to sell licences to greetings-card companies, ceramics manufacturers and makers of stationery and giftware.

Selling licences and working with publishers makes up an important part of many artists' incomes, but few could survive on this revenue alone. Artists often work with publishers as much for the publicity and exposure in the marketplace that this gives them as for the money.

As with any business venture, knowledge is power and the more research you undertake before diving in, the better; it can save you time, money and heartache. The more you understand about licensing and the machinations of the art-print industry, the less likely you are to be left with a warehouse full of unsaleable prints or to be taken advantage of by a licensee or publisher.

You should begin by properly understanding the three avenues of production in the fine-art reproduction industry:

1) Self-publishing artists commission a fine-art printing company to produce prints for them, then undertake the marketing themselves.
2) Self-publishing artists invest in digital-printing equipment, then produce and market their own prints.
3) A publishing company undertakes to print and market an artist's work, and pays the artist a commission on sales.

Options 1 and 2 are discussed in Chapter 15: 'Printing your own work'. Option 3 involves working with a publishing company or giftware manufacturer and either selling a licence to print a particular image for a particular purpose, or selling the copyright in an image. See Chapter 12: 'Copyright and reproduction rights' for a discussion on how copyright is commonly dealt with in the print and licensing industry.

It is worth noting here that artists can also expand the market for their work by producing editions of original prints (such as etchings, screen-prints or engravings), either alone or working in collaboration with a master printmaker at a printmaking studio.

Fine-art print publishers

Fine-art publishing companies range from local galleries with a publishing sideline to international companies that turn over millions of pounds each year. Publishing companies underwrite production costs and handle the marketing and distribution, leaving their artists free to create art all day. If the prints don't sell, the artist is not out of pocket.

Publishers generally pay their artists a royalty of between 8% and 20% of sales proceeds. Don't necessarily be tempted by the publisher offering the highest percentage: it could, for example, prove worthwhile accepting a commission of 8% from a publisher with a long-standing reputation of achieving high-volume sales, rather than 15% from a newly established firm with a minimal marketing budget. You also need to consider the price that the prints are to sell for (for example, you are better off with 8% of £100, rather than 10% of £50). The likely volume of sales is also important: 15% may seem a good deal, but not if only a tiny percentage of the print run actually sells.

Publishers of open editions sometimes agree to pay artists a further fee if images go into reprint. An artist may receive more for a limited edition, as the publisher will rightfully insist that the image cannot be reproduced in any other form. The higher fee is acknowledging that the artist will not be able to earn any more from the image.

Most print publishers sell wholesale, or trade, to galleries; these retailers will then frame the prints and sell them to the public. The retail mark-up on the trade price is generally 100%, i.e. buy for £25 and sell for £50. The artist will thus receive a percentage of the trade price, not the retail price. On the rare occasions when a publisher is selling retail, an artist is likely to receive between 5 and 10% of the retail price, which is approximately the same amount. (Publishers operating in niche markets are the most likely to sell retail, such as those selling dog prints at specialist dog shows or rock and pop images at music festivals.)

Most publishers pay their artists on a quarterly basis, sometimes with an additional upfront payment. In the case of signed limited-edition prints this advance is called a 'signing fee': an artist can spend the best part of a day signing a run of prints. An artist not paid any fee in advance is likely to receive a higher percentage. The quarterly-payment system relies on trust as to when sales are made; in effect, the artist is sharing publisher's risks, but is also rewarded for this commitment if all goes well. A signing fee is often £1 per print, which would, for a typical limited-edition print, amount to a total advance of between £500 and £1,000. Signing fees are generally paid at the time of signing.

Advances vary in size, of course, though £500 is not unusual in the art-print industry. Make sure the contract clearly states whether any advance is in addition to or instead of royalties, or whether it will be deducted from initial royalties.

Publishers are only likely to offer retainers to artists with a proven sales record and with whom they have an established working relationship; even then retainers are rare. However, to ensure loyalty from a 'hot' artist a publisher might agree to pay a retainer of a few thousand pounds a year. In return the publisher is likely to demand a high level of exclusivity.

You need to understand the contract that you have with your publisher (see Chapter 14: 'Contracts between artists and publishers or licensees'). You also need to be clear whether you have sold a licence to produce an image in a particular form or whether you have signed over copyright for that image (see Chapter 12: 'Copyright and reproduction rights').

Licensees in other markets

As well as selling licences to print publishers, many artists also sell permission to print particular images to publishers of greetings cards, stationery, dinnerware manufacturers, stitch-craft kit makers, etc.

It is common for artists to receive single payments rather than royalties in this market, though a royalty is preferable. An established artist is more likely to be granted a royalty. Among a number of factors affecting the size of payments and royalties, not the least is the artist's reputation and sales history.

The average single payment given to artists of course varies enormously, but tends to start at around £150 per image. The variation is so great that the same artist may receive £750 per image from one company and £150 from another. Some licensees pay slightly less for images that have been seen elsewhere, and they may pay a lower rate if they buy a number of licences at once (e.g. for calendars or a set of tableware). Greetings-card companies tend to pay between £150 and £350 per image, plus a small stock of cards. The fee for calendars is often between £75 and £100 per image.

Ceramics manufacturers pay either royalties or flat fees; royalties tend to be a low percentage, between 1-7%, as the volume of sales is high. Artists who sell images for use on jigsaws, cross-stitch patterns and so on can expect anything up to £1,000 per image, depending upon projected sales figures, exclusivity and reputation.

Successful artists may receive royalties in addition to down payments, and they will obviously receive larger down payments. A typical down payment, or advance, from a giftware manufacturer is £50 per image. Where royalties are paid instead of flat fees in the giftware sector, these tend to be slightly lower than those for fine-art prints, often 7-10%. Royalties rarely exceed 10%, largely because the artist's image is only one aspect of the overall product and its design.

As a general rule, artists are paid a low percentage for images that will appear on low-value products to be produced in high quantities. For example, the food industry might only pay a 1%-2% royalty for images that appear on children's food packaging, since projected sales are high. For more specialist or upmarket foods, such as celebration cakes, you might expect 5%-10%. For paper napkins, where tens of thousands would be expected to sell, you might receive around 4%.

You can sell reproduction rights for any number of years: two, three, five, seven and forever are commonly used. It is common for licensees to buy 'exclusive worldwide rights' to use a given image for a given purpose. Licensees do not want the copyright holder to sell licences to, for example, several other dinnerware manufacturers, so they might state, 'The artist will retain full copyright in the artwork, and she may use the same artwork in fields other than dinnerware as she wishes'. However, copyright holders may sell a range of territorial rights: UK rights, world rights, world rights excluding the USA, etc. They may also sell the right to use that image for anything measuring less than, for example, 20 x 10cm; an additional fee may be charged for further uses, and so on. Lastly, it is rare for artists to have control over the size of print runs of cards and calendars.

Where to find publishers and licensees:

Fine Art Trade Guild

The Guild's website and *The Directory* it publishes annually are useful in sourcing print publishers (for details see Appendix: 'Useful contact details'). *Art Business Today* is a trade magazine containing print publishers' advertisements and editorial on the subject.

Reference books, magazines and websites

Listings such as the *Writers' & Artists' Yearbook* are useful. The greetings-card industry also has a trade association and trade magazines (see Appendix: 'Useful contact details').

Trade fairs

Hundreds of card and print publishers, ceramics manufacturers, giftware firms and makers of stationery products exhibit at Spring Fair Birmingham and Autumn Fair Birmingham, for example. Do not approach publishers at shows when they are busy selling, but make notes as to how they might suit your needs and write to them later.

Card shops and publishers' websites

Jot down addresses from the backs of greetings cards. Notice which companies specialise in the appropriate styles and subjects. Check out their websites.

Galleries

Representatives from card and print publishers tend to do the rounds of galleries looking for suitable images. Gallery owners therefore become agents and strike deals on their artists' behalf, usually retaining a percentage for doing so.

Chapter 14

Contracts between artists and publishers or licensees

Many artists are intimidated by the contracts they receive from publishers and licensees. Are they being offered favourable terms? Is the contract unreasonably restrictive? Can they sell the same image again? Can they sell work rejected by their main publisher to other publishers? This chapter looks at some of the clauses that are typically included in most contracts.

You might guess that all publishers' contracts would be pretty similar: lawyers would surely iron out any idiosyncrasies, and in any case art publishing is a relatively small, cohesive industry. To some extent this is true: there are some key areas that are covered in virtually all contracts. However, contracts vary an awful lot in the detail and in how these key points are addressed. These differences probably grow out of the particular experiences of different companies over time; their standard contracts are gradually amended and developed. It is, of course, absolutely vital that you understand any contract you sign. Don't be frightened to ask the publisher to explain points about which you are uncertain.

The best way to protect yourself against a contract that is not in your best interests is to ensure that the publisher you are thinking of

working with is reputable. Of course you need to read the draft contract thoroughly, and make sure that you understand it, but your first step should definitely be to talk to other artists and contacts in the trade about the publisher in question. It is also advisable to get a lawyer to look at the contract; even though there is a cost for this service, it may save a lot of time and money in the long run.

It is important to understand the difference between a 'contract of business' and an 'agreement per picture'. The latter refers to the terms agreed between artist and publisher for the use of a particular image, while a contract of business denotes a longer-term agreement between artist and publisher. Most artists would begin with agreements per picture, and once they have developed a proven sales record they may be given a longer-term contract.

The basics

Any contract or agreement needs to be signed and dated by both parties. The names and addresses of both need to be clearly stated, and it also needs to be clear which party is 'the artist' and which is 'the publisher' or 'the licensee'. Contracts generally start with a brief sentence outlining what the contract is about. For example, 'This letter sets out the terms we have agreed regarding the right of Aardvark Art to reproduce limited-edition prints of the original artwork by John Smith listed on page 6'.

The artwork

The titles of works of art to which the agreement refers must be clearly stated, with an accompanying description if this might help define the works. Alternatively, if the contract refers to all artwork created during a certain period, this must be clearly defined (see 'Timescale' below).

Most contracts comprise a sentence confirming that the artwork is entirely the original work of the artist and does not plagiarise any other work, and that no one else has any claim on its copyright. A statement that the image has not been published before, and the rights to do so have not been previously sold, would be included for limited-edition prints or where copyright rather than a licence is being sold. Most licensees would seek confirmation that the image has not been used before for a purpose similar to their own. Some contracts seek

confirmation that the artwork is not 'substantially similar' to any other works created by the artist, and that the artist will not create any such works in future.

It must be made clear whether the artist still owns the artwork, and thus can grant the publisher access to it for the purposes of photography. It should also be specified that if the work is later sold, the artist would agree to provide the publisher with printing-quality digital files or transparencies. Bear in mind that getting artwork professionally photographed to this standard can be expensive, but if it isn't done you may be unable to exercise your copyright.

Licence or copyright?

Confusion over the difference between selling copyright and selling a licence has the greatest potential to bring you heartache (and loss of revenue). It is essential that you address this subject in any contract or agreement. See Chapter 12: 'Copyright and reproduction rights' for guidelines.

How and where the artwork will be used

The contract must make it clear whether the image is to be published as a limited-edition print of 500 copies, an open-edition print, or a set of playing cards, etc. If you are expected to hand-sign and number an edition of prints, the contract needs to make this clear too.

Some contracts state that production and marketing decisions – to do with size, design, print run, production method, promotional activity, price, date of issue, title, etc. – are at the licensee's discretion. Others claim the right of the licensee to amend the artwork, e.g., to crop borders or use details. Giftware manufacturers may confirm their right to amend an image in order to render it more suitable for their purpose (e.g. to simplify certain aspects of a design so it can be reproduced better onto canvas for stitch-craft kits). Conversely, some licensees confirm that their reproduction will be the most accurate possible facsimile of the original artwork. The contract might also mention that the image can be used by the publisher on promotional material and on its website.

Contracts are likely to state whether they refer to worldwide rights, or cover only those within North and South America, within the EU, etc.

If a geographical area is specified, then you need to clarify whether you are still free to sell licences in other parts of the world.

The artist's royalty

Artists are typically paid royalties in fine-art print publishing, but may be paid a flat fee when licensing images into other markets. Typical payments are discussed in Chapter 13: 'Working with publishers and licensing work' (see the sections entitled 'Fine-art print publishers' and 'Licensees in other markets'). The royalty rate must of course be clearly stated in the contact.

A contract might typically be worded in the following way: 'The publisher will pay the artist a royalty of X% of the net sale price of each print on a quarterly basis commencing on 1 December 2005. Frequency of payment will be reviewed after two years.'

If a print is to be sold mounted and framed, the contract should make it clear how much of the selling price is the print itself, as any royalty will be paid on the print alone.

Advances, upfront payments and retainers

If payment other than royalties is to be made, the details must be specified. Chapter 13: 'Working with publishers and licensing your work' includes guidelines (see the sections entitled 'Fine-art print publishers' and 'Licensees in other markets').

Payment terms

Net sales price is normally defined as the invoiced trade or wholesale selling price, less any agents' commissions, damaged stock, bad debts and discounts. Royalties are not paid on prints given away as free samples, used for display purposes, etc.

Payments are commonly made to artists either quarterly or every six months. Publishers are unlikely to pay their artists until they themselves have been paid, so the contract should make clear whether royalties are paid on, for example, monies actually received in the quarter before the date of the statement.

Some contracts will state that if monies in a given period are less than, say, £100, royalties will be carried over until the next payment date.

They may also state that if debt collectors and legal expenses are incurred in collecting debts, then the proportion of this expense the artist will share will be the same as their royalty rate.

Publishers often renegotiate payment terms after a specified period, often two to five years. Others state that no royalties will be paid on prints sold for less than around 80% of the trade price, or below the cost of printing (e.g. remaindered stock that is heavily discounted for clearance).

Make sure that you understand how VAT will be paid. The situation is similar to that described in Chapter 11: 'Agents', in that most artists are not registered for VAT, while most publishers are. Both parties need to understand where VAT is payable; a worst-case scenario is that one party receives commission that is 17.5% less than they expected, as they forgot to factor VAT payments into their calculations. For example, you should check that the sum a licensee agrees to pay does not include VAT, and that this is specifically stated in the written agreement. If there is a misunderstanding and it turns out that the licensee quotes all payments inclusive of VAT, you will find that your revenue is 17.5% less than you thought it would be.

Timescale

Most sales of licences and copyright extend for the 'full term of the copyright'. However, some card and calendar publishers buy rights for a limited period, maybe three to five years (after this date they are generally allowed to continue selling stock, but not to reprint). Some contracts state that payment schedules and exclusivity agreements will be revised every two to five years. Others run for up to ten years from the publication date of the prints, or as long as the artist's work appears in the publisher's catalogue. Some publishers restrict an artist's right to sell their work to other publishers for a certain length of time (see 'exclusivity' below). Make sure that you understand whether your contract is valid from the date of signing or from the date of publication of the first print. Some contracts automatically renew every three to five years unless either party notifies the other in writing 90 days before the contract expires. Where a flat fee is paid, rather than a royalty, there may be a clause stating that if the contract is renewed a sum of 50% of the initial flat fee will be paid to cover reprints.

Some contracts include a timescale for the publication of the images, which certainly benefits the artist. Otherwise, the publisher could sit on the images for years, while the artist cannot sell licences for those works elsewhere and receives no payment for them.

It is important that you are free to sell your work elsewhere once a contract has terminated, however amicably. It is generally not in an artist's interests to have to wait for a period of time to elapse before being allowed to start selling work again.

Secondary rights and original paintings

If an artist sells copyright, rather than a licence, and the artwork is being reproduced in open-edition format, then the publisher can generally sell reproduction rights to third parties. In some cases the artist signs away any claim to future revenue, while in other cases the artist receives a percentage of such sales. The percentage paid to the artist inevitably varies, but is commonly between 30% and 50% of the net sale price of all secondary rights. If the publisher is not entitled to sell secondary rights, this should be clearly stated in the contract.

Contracts sometimes cover original paintings. The publisher may require a certain number of original works each year (maybe 10 or 12), but allows the artist to sell other works as he or she sees fit. The price to be paid for these original works, along with details of size, subject matter and medium, would be included in the contract.

Exclusivity

An 'agreement per picture' would not include reference to exclusivity or future artwork, whereas a contract might do so. For example, a contract may state that the artist has to give the publisher first refusal on any artwork created within two or perhaps three years of the date of the contract, including any work in progress at the time. It may also state that any sales of licences during this two-year period, even for works created before the agreement was entered into, should be offered first to the publisher. Alternatively, the contract may state that the artist should submit any work to the publisher which the artist thinks would be suitable for publication. Make sure to clarify the terms under which the publisher will buy any licences (e.g., on the same terms as pictures already in publication).

It is essential that you understand the implications of restrictive clauses, such as whether you can sell licences in any work that is rejected by the publisher. Sometimes the publisher requires an artist not to sell their work to competitors for a given length of time; sometimes the artist can sell licences for any use other than the publisher's (e.g. as greetings cards). Occasionally the publisher allows only work in a very different style to be sold elsewhere, or the contract may just restrict the sale of licences in works which are so similar to the works sold to the publisher that they might actually be confused with one another.

Finally, a contract may state that the artist is under no obligation to provide the publisher with more artwork, and that the publisher is under no obligation to buy further licences from the artist. However, once you have a proven sales record with a publisher you might expect your contract to specify a minimum number of prints that will be published each year.

Legal details

There are certain legal clauses which seem to crop up in most contracts, while there are many others which are unique to each publisher. Many contracts include a paragraph stating that the artist will bear the costs of any legal action taken against the publisher which results from the artist breaking any part of the agreement. Most also include a get-out clause for both parties. For example, either party has the right to terminate the agreement if the other breaches the terms of the contract and does not rectify this breach within 30 days of the breach being brought to their attention. Participants are generally required to send a letter by registered post stating that they are breaking the agreement. Artists are also generally allowed to terminate an agreement, by the same process, if the publisher goes into liquidation.

Also common to most contracts is a paragraph stating that the artist is allowed to inspect the publisher's books and accounting records if reasonable notice is given and the artist bears the cost of the inspection. It is sometimes stated that the rights detailed in the contract are not transferable to a third party unless the publisher, or the majority of its assets, is sold, merged or subject to a takeover.

Complimentary merchandise

Some print publishers give a small percentage of each print run to the artist, maybe between one and a hundred prints, depending upon unit value and edition size. Card publishers may give the artist 50 or 100 cards. Sometimes the artist is entitled to further prints or merchandise at a reduced rate, which can be useful for artists who also own galleries and gift shops.

Miscellaneous costs

A good contract should cover as many details as sensibly possible, so take the time to consider any hidden costs. For example, a small publisher may baulk at the cost of shipping heavy bundles of prints to and from an artist's home for signing. While a larger publisher would probably absorb this cost, a smaller firm may agree that the artist pays for delivery one way and the publisher pays the other.

Chapter 15

Printing your own work

In recent years, it has become enticingly inexpensive and straightforward for artists to reproduce their own work, but at the same time the market for selling prints is becoming more and more competitive, and retailers have much higher expectations of their suppliers. In a marketplace where retailers are bombarded with new images at an ever-increasing rate – thanks to the revolution in desktop publishing and digital communication – marketing and a professional approach to sales are more important than ever before. Many artists find the complexities of production so absorbing they forget that marketing and distributing the prints is also likely to be a challenge that requires further investment. So while low production costs make it easier to break into the print market, it is also much harder, and thus more costly, to convince retailers to buy into your brand.

If you do publish your own work you must either employ an agent to sell your prints (see Chapter 11: 'Agents'), or you must sell them yourself. If your work is reproduced by a publisher, all the costs will be borne by the publisher, including the marketing. In return for the investment and risk, both of which are considerable, the publisher gets to retain most of the revenue. Bear in mind the obvious disadvantage if you do self-publish: you will have to underwrite all the costs, and thus cope with the losses if the work does not sell. Another possible drawback is the time you spend printing and selling when you could be producing original work.

If you are a self-publishing artist, you can either commission a printer to produce your work or, if you are computer-literate, you can invest in digital-printing equipment and print your own images.

Commissioning a printer

When artists commission a fine-art printer to make reproductions, they foot the printing bill and are responsible for marketing and distributing the prints. Great care needs to go into selecting a fine-art printer to do the job; many perfectly capable printers blithely assure artists that they can produce art prints, without being aware of the unique pitfalls of this type of printing (see section on 'Print quality' below).

There are two main types of printing process for artists to choose between: offset litho printing and digital printing (the latter creates giclée prints). A third type of reproduction, screen print or silkscreen, is highly thought of by many artists at the top end of the market, but screen prints represent a small percentage of the overall print market. Both digital and offset litho are widely used in the art-print industry, and each has its own distinctive advantages.

Commercial offset litho printing is a long-established process, while digital printing has only been widely used in the UK fine-art print industry since about the year 2000. Offset litho requires the making of printing plates, and a printing machine needs to be set up before each run can be produced; so it is only cost-effective if the whole edition is printed at once. Offset lithos can be printed very quickly, so they usually work out cheaper to print than giclées. The downside is that print runs have to be of a reasonable size to make the run cost-effective, so money is tied up in stock until the stock is sold, and over-production is frequently a problem.

The main advantage of digital printing is that the image stored on a computer can be easily printed out on demand, so digital printing is a cost-effective way for an artist to print a few at a time, spreading costs and avoiding stockpiling. Thus, less capital is tied up in unsold goods. Furthermore, an image can be altered according to the demands of the marketplace (this is not possible if you have printed all the images at the outset).

Some publishers therefore employ a mix of digital and offset litho printing, utilising the advantages of both techniques. They use offset litho for prints they are confident will sell well enough to make it worth paying upfront for a substantial print run; and they use digital printing for more experimental projects.

Offset-litho printing presses, equipment and training are a substantial investment, so printing is generally the core business. However, many offset-litho printers do not specialise in fine-art printing, but instead produce brochures, magazines, etc. Those that do offer fine-art printing should have invested further in developing specialist operational skills in order to understand the intricacies of this type of work.

Many offset-litho printers have also invested in digital-printing equipment; their superior knowledge and experience of printing can be a great asset. However, since digital-printing equipment is relatively inexpensive, there are a growing number of galleries, graphics firms and photographic studios who are offering a digital-printing service to local artists as an additional service and revenue source. The service offered by these firms varies greatly in quality, so make sure that the printer you have in mind is capable of printing high-quality fine-art prints.

Buying your own equipment

Some computer-literate artists decide to invest in their own giclée printing equipment, the cost of which continues to fall. A large-format digital printer, along with a computer, scanner and colour-management software, is probably a sensible initial investment. To this must be added relatively costly consumables and maintenance.

You should not underestimate the technical expertise you will need to produce your own work. Manipulating colours onscreen and ensuring that the printed image is the same as the original requires experience and skill. You also need to be confident that you are using the right combination of software, inks and paper to achieve a lasting image. Time must be spent in keeping abreast of rapidly changing, and often highly complex, technological developments.

When it comes to investing in equipment, there are many choices on the market. There are clear advantages to buying from a specialist fine-

art supplier, who understands the requirements of your marketplace, rather than an anonymous source on the Internet or high street. Servicing and back-up are important issues, so look at the maintenance deals being offered. The Fine Art Trade Guild's website includes details of specialist suppliers.

Print quality

Whether you choose digital or offset litho (or if you have invested in your own printing equipment), you need to be sure that you or your printing company (or your own equipment) is up to the job. You should finish up with prints that meet the technical specifications expected by galleries. You don't want to destroy your hard-earned reputation by selling prints that might leave consumers dissatisfied. Reproductions on paper range from photocopies designed for temporary use through to quality prints that are almost indistinguishable from original paintings, so it is essential to pay attention to the quality of any prints.

If you are outsourcing the work, always check that your chosen printer has done fine-art work in the past; you don't want to bear the costs of trial and error. Ask to see examples of similar work that the printer has done, and find out which other artists and publishers the company works for. (It is worth noting that printer members of the Fine Art Trade Guild have all successfully submitted work to independent laboratory tests to establish that they are capable of printing to Guild standards.)

An important consideration is whether your printer can achieve good colour fidelity to your original work; this is best checked by questioning them about work they have done for other artists, as well as asking the printer to produce some test pieces for you. Colour fidelity is one of the most complex challenges for artists who are printing their own work.

Prints that you intend to register with the Fine Art Trade Guild must meet the Guild's standards, which have become guidelines for the industry as a whole. Only prints that are registered can carry the Guild logo. This mark of quality can play an important role in your marketing, as any customer will be reassured that the print they are buying meets stringent standards.

The Guild's standards state that limited editions cannot exceed 1,950 worldwide, including artist's proofs, though publishers are urged to keep their editions to 1,000 or less. Editions are often limited to 850 for historical reasons (this was the number decreed by the founders of the Printsellers' Association in 1847). The number in the edition is not specified for open editions; it could be many thousands for a popular print or less than a hundred if sales go badly, and of course a publisher can reprint an open edition.

The edition size and variation needs to be comprehensively disclosed to all buyers. 'Variation' refers to whether the print is produced in different sizes; whether it's embellished in some cases with additional signatures or hand-drawn cartouches; or whether there are colour variations within the print run. All variations of the print must fall within the maximum disclosed edition size.

Guild standards also state that if an image has been used for a limited edition, it cannot be used in any other form (e.g. a later edition, greetings cards, a jigsaw puzzle). This too has become an ethical norm for the industry as a whole.

Check that your printer, or supplier of giclée consumables, understands about lightfast inks and archival paper. This is a complex area the importance of which people often underestimate: for example, an ink may only remain lightfast when used with a certain, often relatively expensive type of coated paper, and some colours fade more quickly than others. The Guild standards state that the inks used must score six or above on the Blue Wool Scale (an independent laboratory test certified by the International Standards Organisation). Paper must have a minimum thickness of 250gsm and a pH reading of between seven and ten.

There is a British Standard for fine-art printing (BS 7876:1996), but this focuses on the level of involvement by the artist in the printmaking process. The requirements for paper and ink quality have been aligned with Guild standards.

Marketing and distribution

The market is very competitive; artists often produce prints with only the vaguest notion of how they are going to sell them, and then find it impossible either to sell them direct to galleries or to find distributors.

If you self-publish you also have control over price, and if all goes well you stand to make more profit. However, don't underestimate the strength of a publisher's marketing machine and their expertise in working with printers. Digital printing means that there are more and more self-publishing artists competing for a finite amount of gallery wall space, some of whom are inexperienced, underfunded businesses that quickly go under.

Galleries are increasingly wary of taking on work from new publishers. They need the reassurance of a tried-and-tested brand name, or at least to know that a particular firm has been around for a number of years. A gallery cannot risk working with a supplier who will fail to supply or cannot maintain quality, so many stick with established names.

Thus it is absolutely crucial if you are self-publishing that you understand the cost and complexities involved in marketing your work. Below are some of the areas to consider:

Marketing and promotion

Publishers are the equivalent of well-known brands, and galleries will buy the brands they trust. It costs money to develop awareness of and trust in your brand. Consider carefully how much you can afford to invest in marketing; without sustained investment you are unlikely to succeed. A flourish of publicity at the beginning, and then no more, and galleries will quickly forget about you; all too often artists don't look beyond the cost of publicising the launch of their prints. You cannot expect to send 100 samples to 100 galleries and expect 20 to place repeat orders. Any self-publishing artist needs to consider advertising in magazines; taking stands at trade fairs; buying databases and direct mailing costs; developing a website and e-marketing strategy; printing brochures and other promotional material.

Trade or direct?

Most prints are sold at trade price to galleries and gift shops; only a minority of specialist publishers sells direct to the public (e.g. at country fairs, dog shows or Grands Prix). Each retail sale will bring in more revenue, but related costs may offset apparently greater profits. Trade sales are likely to be for a greater volume of work, and repeat business is more likely. Retail customers expect to pay before taking delivery of their prints, while trade customers expect to open an account, risking cash-flow problems and bad debt, and

making accounting more time-consuming. Retail customers may also want framed prints, which can offer scope for greater profits and but can also create logistical problems.

Pricing

There are prints on the market costing from a few pounds each up to hundreds of pounds (the latter are normally signed by celebrities or are handmade by well-known artists). The reputations of both artist and publisher affect the price that the market will bear. Pricing is an integral part of marketing; your positioning must take into account the level of demand for the artist's work as well as competition in the marketplace. You also need to consider your strategy for quantity discounts, special offers at trade shows, special promotions tied in with your marketing initiatives, etc.

Market position

You need to decide whether you are targeting the exclusive end of the market, or whether your focus is on selling in volume to contract framers; also, whether your work would sell better in open-or limited-edition format. Limited editions range from editions of 50 up to the Fine Art Trade Guild's maximum of 1,950. Some publishers offer their prints mounted and cello-wrapped, which some retailers prefer (at the right price).

Agents

Agents are discussed in Chapter 11: 'Agents'. However, it is appropriate to note here that agents expect back-up from their suppliers, and good marketing support is one way of luring a good agent. Employing an agent is definitely not a way of avoiding marketing costs.

Appendix

Useful contact details

Magazines

a-n magazine
The Artists Information Company
First Floor, 7-15 Pink Lane, Newcastle upon Tyne, NE1 5DW
T: 0191 241 8000
W: www.a-n.co.uk
E: info@a-n.co.uk
12 issues per year.

Art Business Today
16–18 Empress Place, London SW6 1TT
T: 020 7381 6616
W: www.abtonline.co.uk
E: abt@fineart.co.uk
Trade magazine for the art and framing industry. 5 issues per year.

The Artist
The Artists' Publishing Co. Ltd, Caxton House, 63–65 High Street,
Tenterden, Kent TN30 6BD
T: 01580 763315
W: www.theartistmagazine.co.uk
E: sally@tapc.co.uk
12 issues per year.

Artists & Illustrators Magazine
Quarto Magazines Ltd., 226 City Road, London EC1V 2TT
T: 020 7700 8500
W: www.quarto.com/AIM/index.html
12 issues per year.

Art Monthly
4th floor, 28 Charing Cross Road, London WC2H 0DB
T: 020 7240 0389
W: www.artmonthly.co.uk
E: info@artmonthly.co.uk
10 issues per year.

The Art Newspaper
70 South Lambeth Road, London SW8 1RL
T: 020 7735 3331
W: www.theartnewspaper.com
E: contact@theartnewspaper.com
11 issues per year.

Art Review
1 Sekforde Street, London EC1R 0BE
T: 020 7107 2760
W: www.art-review.com
E: info@art-review.com
10 issues per year.

Frieze
3-4 Hardwick Street, London EC1R 4RB
T: 020 7833 7270
W: www.frieze.com
E: info@frieze.com
6 issues per year.

Galleries
Barrington Publications, 54 Uxbridge Road, London W12 8LP
T: 020 8740 7020
W: www.artefact.co.uk
E: ed@artefact.co.uk
Published monthly.

Greetings Today
Federation House, 10 Vyse Street, Birmingham B18 6LT
T: 01442 289930
W: www.ga-uk.org
E: enquiries@ga-uk.org
Trade magazine for the greetings-card, calendar and gift-stationery industry. 10 issues per year.

The Jackdaw
88 Leswin Road, London N16 7ND
T: 020 7249 0230
W: www.stuckism.com/davidlee.html
E: dg.lee@virgin.net
10 issues per year.

Modern Painters
T: 020 7407 9247
W: www.modernpainters.co.uk
E: dharris@ltbmedia.com
4 issues per year.

Picture Business
Unit 1, Hartridge Manor Barn, Paley, Cranbrook, Kent TN17 2NA
T: 0845 370 7037
W: www.picturebusiness.uk.com
E: info@picturebusiness.uk.com
Trade magazine for the picture, print and framing industry. 8 issues per year.

Printmaking Today
99–101 Kingsland Road, London E2 8AG
T: 020 7739 8645
W: www.printmakingtoday.co.uk
E: mail@pt.cellopress.co.uk

Progressive Greetings Worldwide
Max Publishing, United House, North Road, London N7 9DP
T: 020 7700 6740
W: www.greetingcardassociation.org.uk
E: jw@max-publishing.co.uk
12 issues per year. Published by the Greeting Card Association.

RA Magazine
The Royal Academy, Burlington House, Piccadilly, London W1J J 0BD
T: 020 7300 5820
W: www.ramagazine.org.uk
E: ramagazine@royalacademy.org.uk
Published by the Royal Academy of Arts.

Tate Etc
Press Office, Millbank, London SW1P 4RG
T: 020 7887 8959
W: www.tate.org.uk/tateetc
E: tateetc@tate.org.uk
Published by the Tate Galleries.

Exhibiting societies

Federation of British Artists
17 Carlton House Terrace, London SW1Y 5BD
T: 020 7930 6844
W: www.mallgalleries.org.uk
E: info@mallgalleries.com
An umbrella organisation which includes the Royal Institute of Oil
Painters, the Royal Society of Portrait Painters, the Royal Institute of
Painters in Watercolours, the Society of Wildlife Artists, the Royal
Society of Marine Artists, the Hesketh Hubbard Art Society, the New
English Art Club and the Pastel Society.

The Guild of Aviation Artists
Trenchard House, 85 Farnborough Road, Farnborough,
Hants GU14 6TF
T: 01252 513123
W: www.gava.org.uk
E: admin@gava.org.uk

The Guild of Motoring Artists
15 Southover Close, Blandford St Mary, Blandford Forum, Dorset
DT11 9PY
T: 01258 454608
W: www.motorart.co.uk
E: stuart.booth@ukgateway.net

The Guild of Railway Artists
Sunrise, 17 Manor Road, Alcombe, Minehead, Somerset TA24 6EH
T: 01643 708026
W: www.railart.co.uk
E: info@railart.co.uk

Hilliard Society of Miniaturists
Priory Lodge, 7 Priory Road, Wells, Somerset BA5 1SR
T: 01749 674472
W: www.art-in-miniature.org/hilliard.htm
E: hilliardsociety@aol.com

National Acrylic Painters' Association (NAPA)
134 Rake Lane, Wallasey, Wirral CH45 1JW
T: 0151 639 2980

W: www.art-arena.com/napa
E: alan.edwards420@ntlworld.com

The Royal Academy
Burlington House, Piccadilly, London W1J 0BD
T: 020 7300 5664
W: www.royalacademy.org.uk
E: webmaster@royalacademy.org.uk

The Royal Society of British Sculptors
108 Old Brompton Road, London SW7 3RA
T: 020 7373 5554
W: www.rbs.org.uk
E: info@rbs.org.uk

The Royal Society of Miniature Painters
1 Knapp Cottages, Wyke, Gillingham, Dorset SP8 4NQ
T: 01747 825718
W: www.royal-miniature-society.org.uk
E: pamhenderson@dsl.pipex.com

The Royal Society of Painter-Printmakers
Bankside Gallery, 48 Hopton Street, London SE1 9JH
T: 020 7928 7521
W: www.banksidegallery.com
E: info@banksidegallery.com

The Society of Botanical Artists
1 Knapp Cottages, Wyke, Gillingham, Dorset SP8 4NQ
T: 01747 825718
W: www.soc-botanical-artists.org
E: pam@soc-botanical-artists.org

The Society of Equestrian Artists
26 Doglands Farm, Newton by Toft, Faldingworth, Lincs LN8 3NG
T: 01673 885537
W: www.equestrianartists.co.uk
E: membership@equestrianartists.co.uk

The Society of Wood Engravers
3 West Street, Oundle, Northants PE8 4EJ
T: 01832 275028

W: www.woodengravers.co.uk
E: g.waddington@dial.pipex.com

Other organisations

Anti Copying in Design (ACID) Ltd
PO Box 5078, Gloucester GL19 3YB
T: 0845 644 3617
W: www.acid.uk.com
E: help@acid.uk.com

Artists' Collecting Society
17-19 Galway Road, London W2 4PH
T: 0845 11122400
W: www.artistscollectingsociety.org.uk
E: info@artistscollectingsociety.ogg.uk
An agency set up to collect fees for the Artist's Resale Right.

The Arts Council
14 Great Peter Street, London SW1P 3NQ
T: 0845 300 6200
W: www.artscouncil.org.uk
E: enquiries@artscouncil.org.uk
Organises government expenditure on the arts and publishes booklets
on obtaining public funding.

The Association of Illustrators
2nd floor, 150 Curtain Road, London EC2A 3AR
T: 020 7613 4328
W: www.theaoi.com

AXIS
Visual Associations, Round Foundry Media Centre, Foundry Street,
Leeds LS11 5QP
T: 0870 443 0701
W: www.axisartists.org.uk
E: info@axisweb.org
Database of information on visual artists.

The British Council
10 Spring Gardens, London SW1A 2BN
T: 0161 957 7755

W: www.britishcouncil.org
E: general.enquiries@britishcouncil.org
Promotes British art around the world and arranges lectures and e
xhibitions.

Business Design Centre
52 Upper Street, Islington, London, N1 0QH
T: 020 7359 3535
W: www.businessdesigncentre.co.uk
E: bdc@businessdesigncentre.co.uk
Organises, among others, the Art Fair London in January each year.

Clarion Retail
Earls Court Exhibition Centre, London SW5 9TA
T: 020 7370 8200
W: www.topdraweronline.com
E: info@clarionevents.com
Organise gift fairs including Home + Gift, Top Drawer and Pulse.

The Crafts Council
44a Pentonville Road, London N1 9BY
T: 020 7278 7700
W: www.craftscouncil.org.uk
E: reference@craftscouncil.org.uk
Publish 'Craft' magazine and other handbooks for craftspeople, as
well as arranging exhibitions and running a library.

Design and Artists Copyright Society
33 Great Sutton Street, London EC1V ODX
T: 020 7336 8811
W: www.dacs.co.uk
E: info@dacs.org.uk
An organisation set up to protect artists' copyright and, from 2006, to
collect the Artist's Resale Right. Artists pay a small fee and are pro-
vided with extensive support and information.

Fine Art Trade Guild
16–18 Empress Place, London SW6 1TT
T: 020 7381 6616
W: www.fineart.co.uk
E: info@fineart.co.uk
The trade association for all those in the art and framing industry.

The Greeting Card Association
Max Publishing, United House, North Road, London N7 9DP
T: 020 7619 0396
W: www.greetingcardassociation.org.uk
W: gca@max-publishing.co.uk

Printmakers Council
Ground Floor Unit, 23 Blue Anchor Lane, London SE16 3UL
T: 020 7237 6789
W: www.printmaker.co.uk/pmc
E: pmcbox@printmaker.co.uk

The Scottish Arts Council
12 Manor Place, Edinburgh EH3 7DD
T: 0131 226 6051
W: www.scottisharts.org.uk/
E: help.desk@scottisharts.org.uk

The Society of London Art Dealers
Ormond House, 3 Duke of York Street, London SW1Y 6JP
T: 020 7930 6137
W: www.slad.org.uk
E: office@slad.org.uk
Membership includes most of the leading art dealers in London.

Trade Promotion Services
19th floor, Leon House, 233 High Street, Croydon CR0 9XT
T: 020 8277 5800
W: www.springfair.com and www.autumnfair.com
E: info@emap.com
The organisers of the Spring Fair Birmingham and Autumn Fair
Birmingham. Hundreds of card and print publishers, giftware
manufacturers, etc. exhibit at these shows.

Index